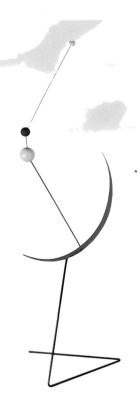

Calder

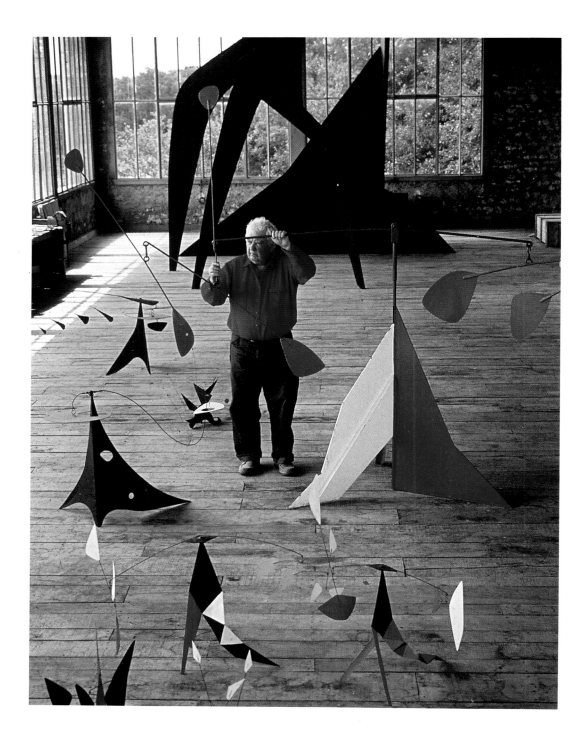

Calder
1898–1976

Jacob Baal-Teshuva

TASCHEN

KÖLN LISBOA LONDON NEW YORK PARIS TOKYO

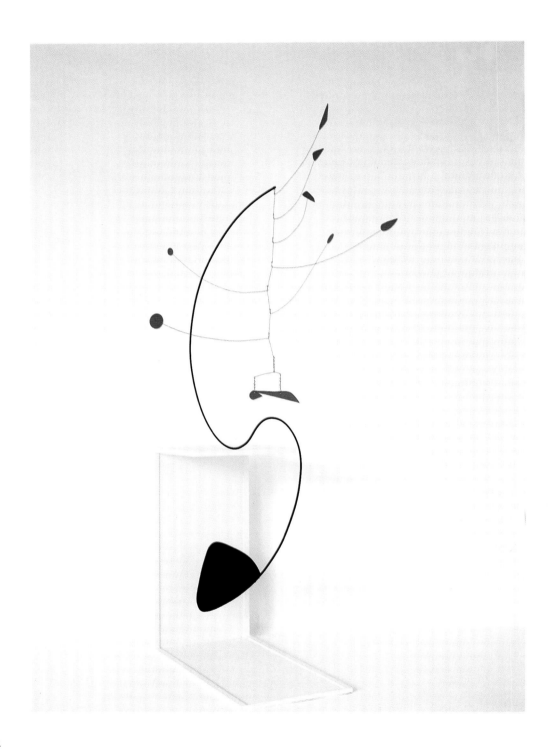

Alexander Calder
1898–1976

Alexander Calder is one of the most important innovators in 20th-century sculpture. One of America's best-loved artists, he also ranks among the most acclaimed contemporary sculptors on the international scene. Like almost no other, "Sandy" Calder – as he was known to his wide circle of friends – caught the spirit of his times by making movement, motion and colour the central elements of his sculptural work.

His wind-driven mobiles in many sizes, shapes and colours made him world-famous. Metal discs attached to moving wires are set in motion by no more than a breath of air, unfolding complex, endlessly fascinating kinetic sequences. With their delicately balanced system of equivalent elements, the mobiles seem to defy gravity. For Calder, the biomorphic shapes of his sculptures symbolised the universal movement of the solar system and life. "The basis of everything I do is the universe," he said.

Calder's mobiles changed the principles of plastic art. For centuries sculpture had been considered the opposite of the mobile, which is fleeting and changeable. The artist's novel 'mobile' sculptures made him a pioneer and leading exponent of kinetic sculpture.

Parallel to the mobiles he created *stabiles*, static sculptures made of metal plates screwed together, and in the 60s and 70s escalated both into the monumental. As urban sculptures gracing many of the world's public places, these giant mobiles and stabiles enjoyed and continue to enjoy great popularity internationally.

Besides these two major parts of his oeuvre, Calder also produced paintings – he started out on his artistic career as a painter – as well as drawings, colourful gouaches, witty toys, jewellery, tapestries and household objects. He also became renowned for his book illustrations, graphic works and painted airplanes and cars. The catalogue raisonné compiled by his grandson, Alexander S. C. Rower, lists so far over 16,000 works.

Among contemporary sculptors, Calder was almost peerless in his love of experimentation. With boundless energy and curiosity he tried out every kind of material capable of being sculpted. For his mobiles he used quite unlikely, unprepossessing everyday objects such as coffee tins, sardine cans, matchboxes and pieces of colour-

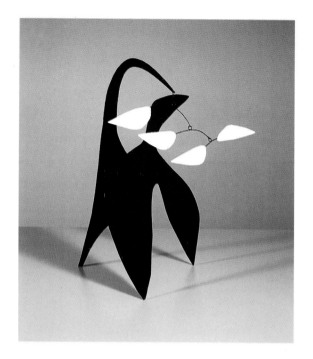

Four White Petals, c. 1947
Stabile-mobile, painted metal , 41.9 x 24 x 36.8 cm
Private Collection
Courtesy Waddington Gallery, London

PAGE 4:
Untitled, 1956
Mobile on a table, steel and wire,
painted black and orange, H 234 cm
Duisburg, Wilhelm Lehmbruck Museum
Purchased with funds from the Peter Klöckner Trust, 1986

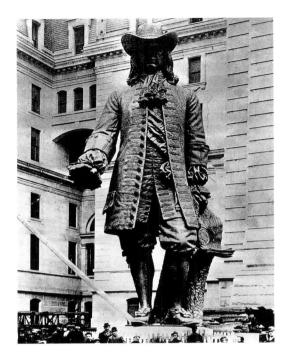

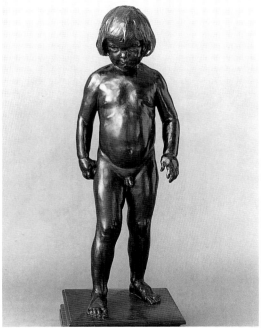

ed glass. His preferred materials were wood and later metal, strikingly painted in the primary colours red, yellow and blue, or in black and white.

Calder made an original contribution to portraiture with his wire figures, which significantly extended Cubist and Futurist achievements in sculpture. He did portraits of many of his friends in this medium. He always had a pair of pliers in his back pocket, ready to do another wire portrait, or fashion a piece of wire jewellery right there and then for a friend.

Calder liked to leave the interpretation of his works to others. "One of the problems confronting me," the artist said, "is to get enough free time to work and not to go around talking about it." Celebrated contemporaries such as the art historians Meyer Schapiro and James Johnson Sweeney, artist friends such as Fernand Léger, Joan Miró and Jules Pascin, or the writer Jean-Paul Sartre have filled this evaluative gap, providing glowing accounts of his work.

A bear of a man, Calder loved life. The red flannel shirt he was always to be seen in became legendary. His trousers were invariably baggy, and his work shoes forever dusty. At an advanced age he had a head of bristly white hair. Calder loved his family, dancing, good wine and parties. His sunny nature won him numerous friends, among them, many of the most famous and acclaimed artists of the 20th century.

Early and formative years – the search for expression
Alexander "Sandy" Calder was born on 22 July 1898 in Lawton, today a suburb of Philadelphia. "I always thought I was born on 22 August 1898 – at least that was what my mother told me [...] But in 1942, when I wrote to Philadelphia City Hall, enclosing one dollar, to get a birth certificate, they told me I was born on 22 July 1898. I sent them another dollar, asking them to have a second look, but they stuck by their first statement ..."

Calder was born into a family of artists. His grandfather, Alexander Milne Calder, who hailed from Aberdeen in Scotland, and his father, Alexander Stirling Calder, had both been respected academic sculptors, executing public commissions for large statues in the Neo-Classical tradition. In Philadelphia they created numerous large-scale allegorical statues. In 1894 his grandfather made a sculpture of William Penn (ill. p. 6), the Quaker founder of the city. Cast in bronze, the work was some 11 metres high, took 20 years to complete, and

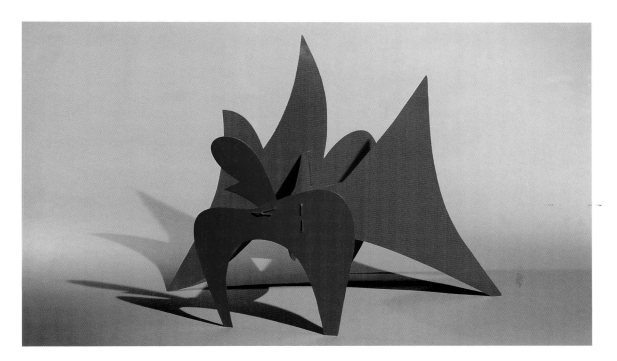

weighed more than 272 kilograms. It was so heavy that it had to be hoisted onto the roof of Philadelphia City Hall in 13 sections.

Calder's father studied at the École des Beaux-Arts in Paris under Alexandre Falguière and in Philadelphia with Thomas Eakins. In the USA he produced academic sculptures for a variety of cities, including the statue of George Washington (1918) in New York's Washington Square. Stylistically, the influence of the father and grandfather left no trace on Calder, grandson Sandy distancing himself from their academic tradition. But the impact of his forefathers was felt in his familiarity with handling public sculptural commissions. Like father and grandfather, he worked closely with architects, relating his sculptures to their destined surroundings.

As a child, Calder served many times as a model for his father. One of Calder senior's sculptures, *Man Cub* (1901–02, ill. p. 6), is today part of the collection of the Metropolitan Museum of Art in New York. Sandy's mother, Nanette Lederer, was a professional portrait painter, and the young Calder also sat for her. Between 1905 and 1909 the family moved several times owing to the poor health of Sandy's father. They went to Oracle,

The Cow (La Vache), 1970
Stabile, painted steel (maquette), 51.5 x 63.5 x 43.2 cm
Private Collection
Courtesy Waddington Gallery, London

PAGE 6 TOP:
Alexander Milne Calder
William Penn, 1894
Bronze, 11.2 m
Philadelphia (PA), City Hall

PAGE 6 BOTTOM:
Alexander Stirling Calder
Man Cub, 1901–02
Bronze, 117 x 38.6 x 34.8 cm
Philadelphia (PA), Pennsylvania Academy of Fine Arts
Gift of Mrs. A. Stirling Calder

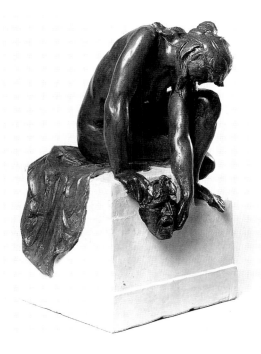

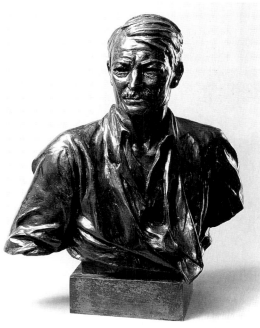

Arizona, and later to Pasadena, California. There were other moves, driven by his father's quest to obtain sculptural commissions. In 1910 the family moved to New York, and two years later they were in San Francisco, where Stirling Calder was appointed chief of sculpture for the Panama-Pacific Exposition (1915) in San Francisco.

Back in New York, Alexander Calder enrolled in the Stevens Institute of Technology at Hoboken, New Jersey, graduating in 1919 with a degree in mechanical engineering. This training was later to help him enormously in mastering technical problems encountered while working on his sculptures. Subsequently Calder took in a variety of jobs in New York, Missouri, Ohio, West Virginia and Washington. His first job, as an automobile engineer, lasted only two weeks, after which he worked as a draftsman for the Edison Company in New York. Then followed employment on the Saint Louis business journal *Lumber*, as a claims adjuster for an insurance company, as a lawnmower representative, bookkeeper, salesman, assistant to a hydraulic engineer, and in a lumberyard. For a while in New York he did lettering for the Association of Inventors.

All these jobs bored him. He decided he wanted to become an artist and in 1922 attended evening classes in nude drawing given by the painter Clinton Balmer, one of his father's friends. But conventional nude drawing soon bored him too. In June 1922 he left New York to travel as a fireman on a freighter bound for San Francisco and South America. On board the *H. F. Alexander*, Calder had an experience that was to determine his whole future career. Early one morning, off the Guatemalan coast, he awoke on the ship's deck to see an amazingly large red ball. It took him several minutes to realise that this was actually the sun. Looking in the opposite direction, he saw the silvery moon. That Calder was deeply impressed by this sight, can be seen in subsequent oil paintings and gouaches, featuring that fiery red orb, the rising sun.

In the wake of this experience, Calder resolved to become a painter. His family encouraged him in his plan, and in 1923 he enrolled in the Art Students League in New York, where he studied under Thomas Hart Benton, Guy Pene du Bois, George Luks, John Sloan and others. Three years later he left the art school and for some years painted landscapes and cityscapes under the influence of John Sloan.

Calder earned his first money from art in 1924, when he became a freelance illustrator for the *National*

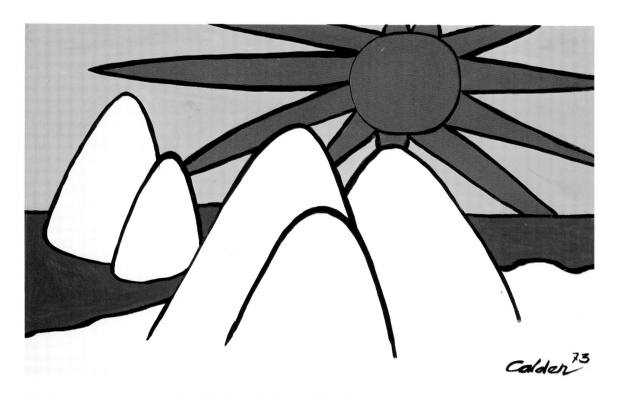

Police Gazette. In 1925, in connection with this work, he received a two-week ticket for *Ringling Brothers and Barnum & Bailey's* circus, which was to spark a lifelong interest in the big top. "I spent two full weeks there, practically every day and night. I could tell by the music what act was just coming on and used to rush to get some vantage point. Some acts were better seen from above, and others from below. At the end of those two weeks I took a half-page sketch to Robinson, the editor of the *Police Gazette*. He said: 'We can't do anything with these people – the bastards never send us any complimentary tickets ...'. I always loved the circus ... So I decided to make a circus, just for the fun of it." In 1926 Calder realized his dream with the legendary *Cirque Calder* (ill. p. 16–17) in miniature format. It was at the circus with its rapid sequence of events that Calder trained his powers of observation and fluent line. And it was not long before he became known for his skill in representing movement and for his satirical undertone – as can be seen, for example, in his illustrations on the theme of Charlie Chaplin's film *The Gold Rush*.

Arctic Sunset, 1973
Red, yellow and blue gouache and black ink
on wove paper, 74.3 x 109 cm
Washington (DC), National Gallery of Art
Gift of Mr. and Mrs. Klaus G. Perls
Photo: Lee Ewing

PAGE 8 TOP:
Alexander Stirling Calder
Naiad with Tragic Mask, c. 1920
Plaster, painted green and white with evidence of gold leaf
41.2 x 24.6 x 28.5 cm
Philadelphia, Pennsylvania Academy of Fine Arts
Purchased with funds provided by the Pennsylvania Academy's
Collectors' Circle

PAGE 8 BOTTOM:
Alexander Stirling Calder
Robert Henri, 1934
Bronze, 81.2 x 63.5 x 45.7 cm
Philadelphia, Pennsylvania Academy of Fine Arts
Gift of Mrs. A. Stirling Calder

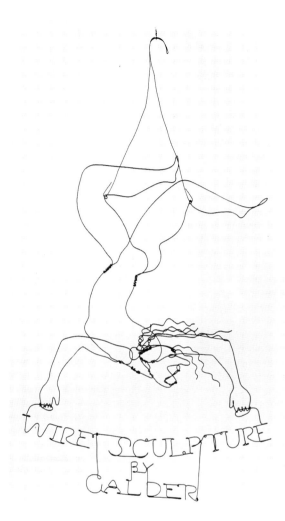

Wire Sculpture by Calder , 1928
Wire, 125.73 x 66.4 x 15.24 cm
New York, Whitney Museum of American Art
Purchased, with funds from Howard and Jean Lipman

In the spring of 1926 Calder published his first sketchbook, *Animal Sketching*, a collection of drawings made in New York's Zoological Garden. The same year also saw him produce his first wire sculpture, a sundial in the form of a cock. Taking line flow over into the three-dimensionality of shaped steel wire, Calder tapped into completely new possibilities for playfully and effortlessly creating in real space. Empty space appears as a constituent element, while volume is reduced to an abstract calligraphic line in space. A group exhibition, held in the Artists Gallery in New York, included paintings by Calder. The same year he created his first wooden sculpture *Flat Cat*.

Art metropolis Paris

In June 1926 Calder left New York to travel to Europe. Again he had taken a job on a ship, the *Galileo*. After 17 days he reached London, where he spent three days, before travelling on to Paris. At first he did not know a soul there, and lived very frugally. Attending the *Académie de la Grande Chaumière*, he quickly made friends among the artists of Montparnasse. During those first Paris days he sculpted small animals and toys out of curtain rings and steel wire. For Calder it was a logical extension of his love of animals and his fascination with playthings. These small experimental sculptures were the immediate forerunners of his first significant artistic production of the miniature Circus. They also anticipated his wire sculptures. Calder had already started down this avenue at the tender age of eight, making toy figures for his sister Peggy's dolls out of wire, scraps of wood and other materials. These childhood creations show signs of the special talent and economy of line and form that came to fruition in the mature artist. From early youth he had had both a feeling for motion, movement and form and a sense of humour and playfulness, elements that later became the hallmark of his artistic work. His childlike playfulness remained with him all his life, although over the years the humour was honed to increasing levels of sophistication.

The avant-garde ambience of Paris in the mid- to late 20s was enormously stimulating for Calder. Sculptors and painters he met there from the milieu of Surrealism and Constructivism, such as Julio González, Antoine Pevsner, Lászlo Moholy-Nagy, Naum Gabo, Joan Miró, Piet Mondrian, Pablo Picasso and Fernand Léger were of immense significance for his further artistic de-

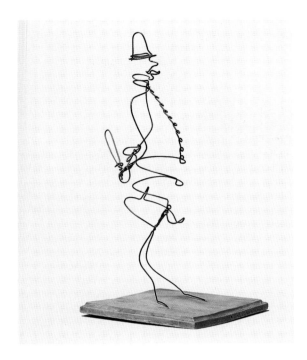

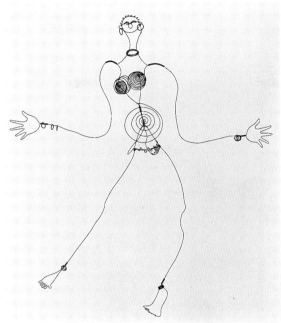

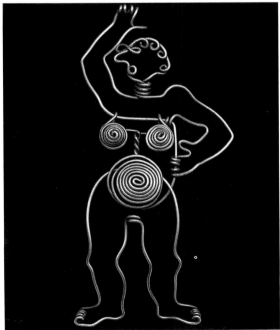

TOP LEFT:
The Constable, c. 1930
Wire, 53.3 x 22.2 x 22.2 cm, Private Collection
Courtesy R. Kaller-Kimche, New York

TOP RIGHT:
Josephine Baker, c. 1928
Wire, H 96.5 cm
Paris, Musée national d'art moderne, Centre Georges Pompidou

BOTTOM:
Belt Buckle, c. 1935
Brass wire, 21.9 x 13 x 4.4 cm
New York, Whitney Museum of American Art
Gift of Mrs Marcel Duchamp, in memory of the artist

PAGE 13 TOP:
**Fernand Léger with a wire sculpture portrait of himself by
Alexander Calder**, c. 1943, Photo: AKG Berlin/Walter Limot

PAGE 13 BOTTOM:
Romulus and Remus, 1928
Wire and wood, 77.5 x 316.2 x 66 cm
New York, The Solomon R. Guggenheim Museum
Gift of the artist, 1965; Photo: David Heald
© The Solomon R. Guggenheim Museum, New York

velopment. The French capital was also home to many American artists, including numerous jazz musicians. The depreciation of the franc after the war and the enhanced buying power of the dollar made Paris particularly attractive for Americans. Since 1925 the black dancer Josephine Baker, the star of the *Revue Nègre* at the *Folies-Bergère*, had been enthralling the whole of Paris. Calder was so struck by her personality that he made a number of wire sculptures of the danseuse, lovingly caricaturing her lithe body and performance. The flexible material and the possibility of moving individual parts were a humorous counterpart to her suppleness, agility and sensuality. Calder suspended some of these Josephine Baker sculptures on strings from the ceiling – a further step on the way to the wind-driven mobiles.

The figures of his celebrated *Cirque Calder*, on the other hand, which Calder had been working on since spring 1927, were not just movable. Calder himself acted as ringmaster and operator in their midst. Like a child, he sat in the middle of his "toy", bringing to life with sounds and movements clowns, tightrope walkers, musicians and animals made out of wire, cork and other scrap materials. These performances, to the music of the then-popular song *Ramona*, were fêted in Parisian artist circles, taking place before audiences large and small. Calder's spectators included artists such as Jules Pascin, Joan Miró, Man Ray, Fernand Léger, Hans Arp, Frederick Kiesler, Theo van Doesburg, Jean Cocteau, Tsuguharu (Léonard) Foujita or Piet Mondrian, as well as art critics, composers and sundry bohemians. His interest in the miniature circus lasted for over thirty years, by which time the troupe had grown to 50 figures. As a kinetic spatial composition with elements of serendipity, surprise and tension, *Cirque Calder* prefigures the later mobiles. The documentary film *Cirque Calder*, shot by Carlos Vilardebo in Paris in 1961, shows the last performance in Calder's house in France. And on the literary front, the writer Thomas Wolfe recorded Calder's Circus in an episode of his book *You Can't Go Home Again* (1940).

Intermezzo in the USA

After a short trip in 1926, Calder returned to the USA in autumn 1927 for a longer period. Presumably he wanted to find buyers for his toy figures and arrange some sculpture exhibitions. In 1928 his wire sculptures were shown at the Weyhe Gallery in New York. Here too his *Cirque Calder* made its New York debut. During the annual exhibition of the New York Society of Independent Artists at New York's Waldorf Astoria hotel, Calder presented his giant wire sculpture *Romulus and Remus* (1928, ill. p. 13), which caused a sensation among passers-by. Sandy's father, who went to the exhibition, was also amused by the work.

Back in Paris

On the strength of a number of commissions, Calder earned enough money to be able to return to France in November 1928, crossing the Atlantic first class on the *DeGrasse*. In Paris he rented a new studio at Rue Cels 7 and met Miró and Pascin. In his autobiography (*An Autobiography with Pictures*), published in 1966 in New York, Calder describes his meeting with Miró thus: "One day I went to Montmartre to see Miró [...]. He was very affable and showed me one or two of his new works, the rest having been sent to Brussels for a show. One of them was a big sheet of heavy grey cardboard with a feather, a cork, and a picture postcard glued to it. There were probably a few dotted lines, but I have forgotten. I was nonplussed; it did not look like art to me. One or two years later I traded one of my works for a large canvas of Miró's [...]. Miró arrived at my studio one day when I happened to be performing my Circus. I guess he enjoyed it. A few years later, in 1932, having seen another Circus performance in his house in Montroig, Spain, he told me next morning: 'I liked the bits of paper best.' These are little bits of white paper with a hole and a slight weight on each one that jiggle down several variously coiled thin steel wires in such a way that they look like doves fluttering down onto the shoulders of a bejewelled circus 'belle dame'."

Calder's friendship with Miró had a profound influence on his stylistic development. Miró encouraged him to invent fantastic animal shapes, which were later to appear – in modified form – in the biomorphic forms of his mobiles. Miró's abstract-surreal pictorial language also stimulated Calder to do paintings and gouaches of his own. During the early 30s the artist also came into contact with other representatives of Surrealism such as André Masson, Hans Arp, Max Ernst and Yves Tanguy.

In January 1929 Calder had his first solo exhibition in Paris at the Galerie Billiet-Pierre Vorms. He showed wire sculptures and also figurative wooden pieces, which, unlike the spatially permeable wire figures, were fully plastically worked. Most of his wooden pieces had

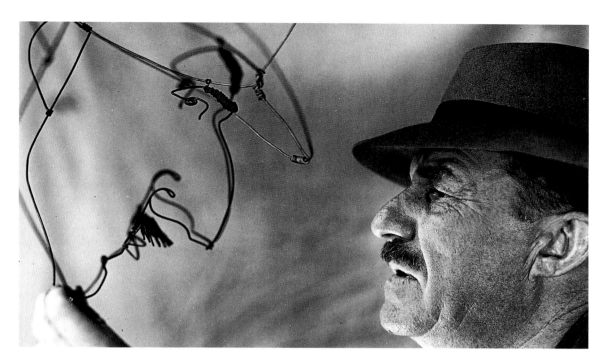

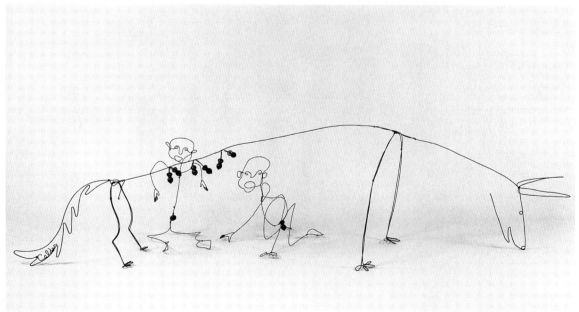

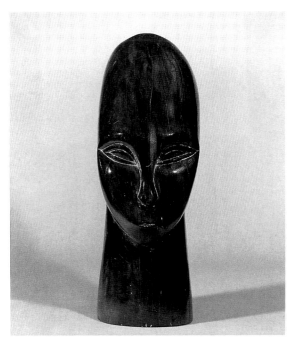

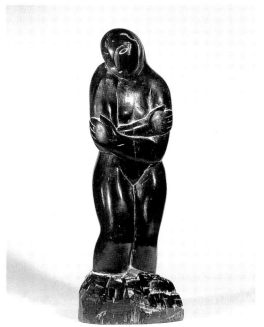

African Head, c. 1928
Stained wood, H 38.2 cm
New York, The Metropolitan Museum of Art
Gift of Charles Oppenheim Jr., 1966

TOP RIGHT:
Woman, 1926
Wood, H 49.5 cm
New York, The Metropolitan Museum of Art
Gift of Charles Oppenheim Jr., 1967

PAGE 15:
The Brass Family, 1929
Brass wire and painted wood, 168.6 x 101.6 x 20.3 cm
New York, Whitney Museum of American Art
Gift of the artist

already been done in the spring and summer of 1928 in New York. In the preface to the catalogue Calder's friend Pascin wrote amusingly: "By I don't know what miracle I became a member of a group of the elite in American art. [...] Through the same chance I met [Calder's] father, Stirling [...]. I think that Stirling Calder is one of the best American sculptors and also the most handsome man in our society. Coming back to Paris, I met his son, Sandy, who at first sight deceived me quite a bit. He is less handsome than his PAPA, frankly! But after seeing his works, I know that he will soon assert himself, despite his foul language, and exhibit with a smashing success next to his PAPA and other great artists, such as I, Pascin, who is telling you this." While the witty wire sculptures caught the attention of the public, the wooden figures were regarded as somewhat conventional.

On the way to abstraction
In June 1929 Calder sailed on the *DeGrasse* back to New York. During the Atlantic crossing he got to know Louisa James (a relative of the writer Henry James), whom he married two years later. The husband-to-be introduced himself to his parents-in-law as a wire sculptor and on

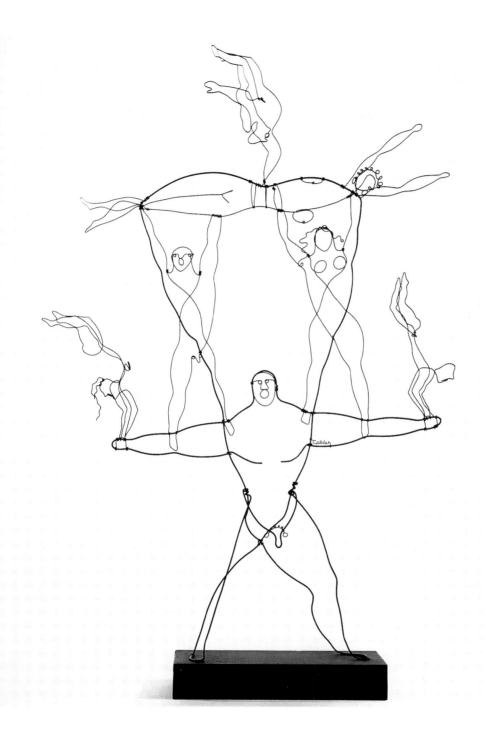

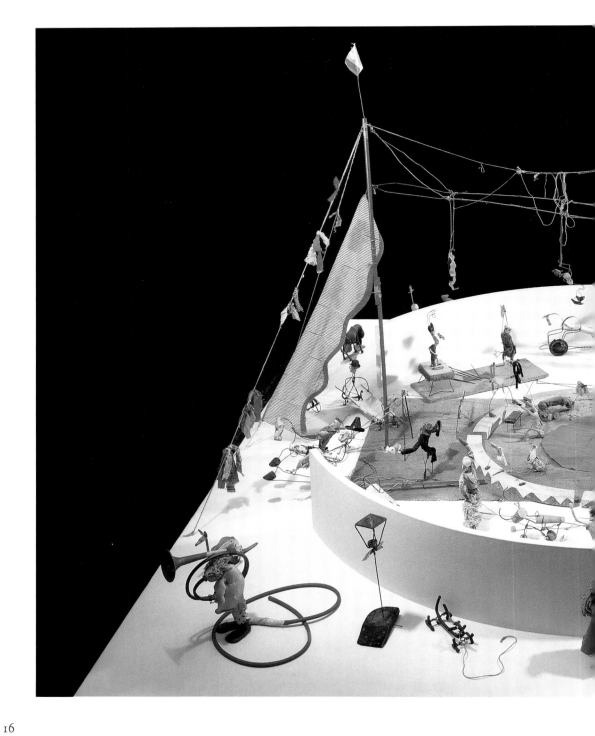

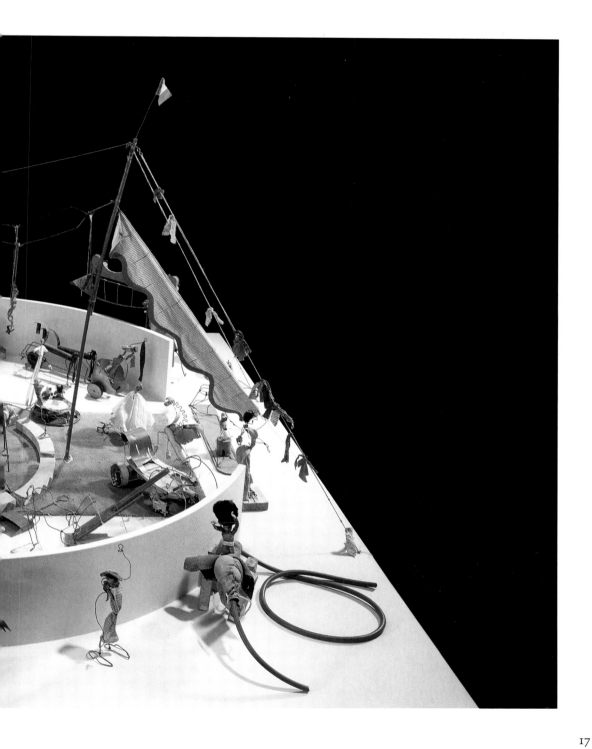

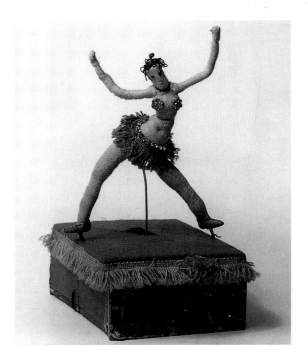

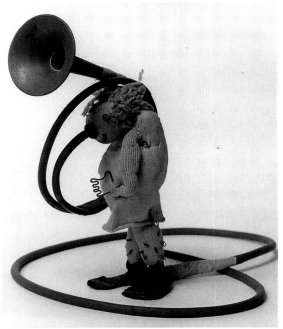

Fanny, the Belly Dancer (from the *Cirque Calder*), 1926–1930
Wire, cloth, rhinestones, thread, wood and paper
29.2 x 15.2 x 26.7 cm
New York, Whitney Museum of American Art

Little Clown, the Trumpeter (from the *Cirque Calder*), 1926–1930
Wire, cloth, yarn, thread, rhinestone buttons, electrical tape,
rubber tubing and metal horn, 29.21 x 11.43 x 19.05 cm
New York, Whitney Museum of American Art

PAGES 16–17:
Cirque Calder, 1926–1930
Mixed media: wire, wood, metal, cloth, yarn, paper, cardboard,
leather, string, rubber tubing, corks, buttons, rhinestones,
pipe cleaners and bottle caps, Dimensions variable; Overall:
137.2 x 239 cm; Accessoires overall: 194.3 x 248.3 x 254.7 cm;
New York, The Whitney Museum of American Art; Purchased
with funds from a public fund-raising campaign in May 1982.
One half of the funds was contributed by the Robert Wood
Johnson Jr. Charitable Trust. Additional major donations were
given by the Lauder Foundation; the Robert Lehman Founda-
tion, Inc.; the Howard and Jean Lipman Foundation, Inc.; an
anonymous donor; the T. M. Evans Foundation, Inc.; MacAn-
drews & Forbes Group, Inc.; the De Witt Wallace Fund, Inc.;
Martin and Agneta Gruss; Anne Phillips; Mr and Mrs L. S.
Rockefeller; the Simon Foundation, Inc.; Marylou Whitney;
Bankers Trust Company; Mr and Mrs Kenneth N. Dayton; Joel
and Anne Ehrenkranz; Irvin and Kenneth Feld; Flora Whitney
Miller. More than 500 individuals from 26 states and abroad
also contributed to the campaign.

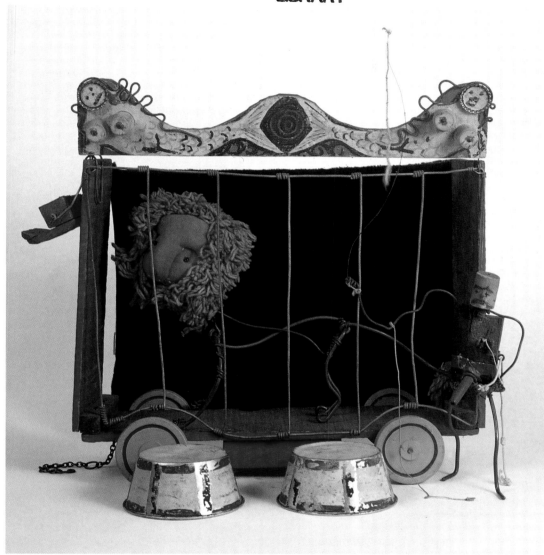

Lion Tamer (from the *Cirque Calder*), 1926–1930
Wire, wood, metal, cloth, leather and string;
platforms: painted metal, 49.5 x 16.8 x 25.7 cm
New York, Whitney Museum of American Art

19

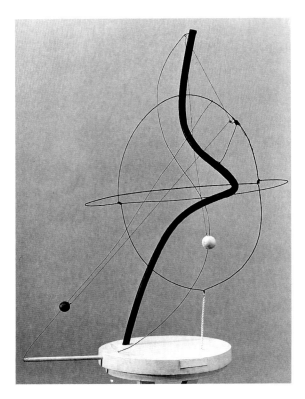

A Universe, 1934
Motor-driven mobile: painted iron pipe, wire
and wood with string, H 102.9 cm
New York, The Museum of Modern Art
Gift of Abby Aldrich Rockefeller
© 1998, The Museum of Modern Art

PAGE 21:
The Bicycle, 1968
(Free reconstruction of "The motorized mobile that
Duchamp liked" of c. 1932)
Motor-driven mobile of wood, metal, cord and wire
156 x 149.7 x 66.2 cm
New York, The Museum of Modern Art, Gift of the artist
© 1998, The Museum of Modern Art

the eve of the wedding, on 17 January 1931, performed
his mini Circus in their house in Concord, Massachu-
setts. At the beginning of 1930 he returned to Paris.

The year 1930 saw radical changes in his artistic ap-
proach. He abandoned wire and wood sculptures to fo-
cus on abstract constructions. A crucial factor in this
change was a visit to Piet Mondrian's studio in the Rue
du Départ. "Mondrian's large, light, irregularly propor-
tioned studio seemed to be one of his paintings trans-
posed into space. The immaculate white of the walls was
interrupted by removable rectangles in red, blue or yel-
low. The red cube of the phonograph in the middle of the
room accentuated the calm of the proportions [...], the
lights came in from the left and from the right, crossed
each other, and I imagined at this moment how beautiful
it would be if everything started to move. But Mondrian
did not approve of my idea. I came home and tried to
paint. But I was always much more stimulated by a piece
of wire or some other material easy to bend, twist or tear
[...]. I think that at that time and practically ever since
the underlying sense of form in my work has been the
system of the universe, or a part of it. For that is rather a
large model to work from. What I mean is the idea of de-
tached bodies floating in space in different sizes and
densities, perhaps also in different colours [...], some at
rest, and others moving [...]." Calder remained a friend
of Mondrian until his death, in spite of the fact that the
founder of Neoplasticism was not interested in kinetic
art. The two artists shared a passion for cosmic ques-
tions and a penchant for dancing.

Another factor prompting the transition to abstract
forms was his joining of the Parisian group *Abstraction-
Création*, founded in 1931 by Auguste Herbin, George
Vantongerloo, Hans Arp, Albert Gleizes, Jean Hélion,
Georges Valmier and František Kupka. Among the
group's members were Robert Delaunay, Theo van Does-
burg, Naum Gabo, Wassily Kandinsky and Piet Mon-
drian. In the same year Calder exhibited his first abstract
wire sculptures at the Galerie Percier. Fernand Léger
wrote in the catalogue: "Calder takes something from all
these scattered elements of our modern times, and it is
fitting that the man who has done all this should be this
big fellow, a one-hundred-per-cent American. Bringing
all the loose ends together, he has imposed order, has
transformed them into sculptural objects and then, al-
ways smiling, has pressed a magic button, and every-
thing begins to revolve slowly, gracefully [...]."

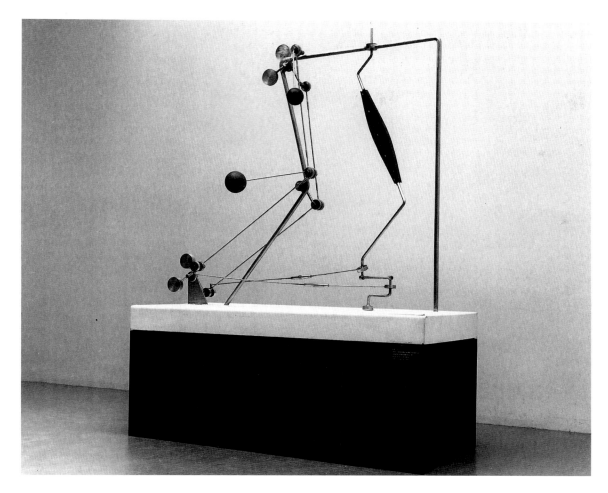

Calder had hit on this theme during a visit to the Paris planetarium. "It was a moment of delight for me when they wanted to show me how the machinery worked, and I caught sight of a planet moving in a straight line, which suddenly turned through 360 degrees, before continuing again on its alloted path." This experience of floating celestial bodies moving in cosmic space according to their own ryhthms and mutual attraction inspired him to do a series of sculptures like *A Universe* (ill. p. 20).

Mobiles and Stabiles
The 1930s was one of the most richly innovative decades in Calder's career. At this time he began to achieve inter-national recognition as a contemporary sculptor. After his planetary constructions he created geometrical two- or three-dimensional forms: rectangles, discs, spheres, spindles, spirals, which perform dancing movements in front of a wooden board acting as a pictorial or stage backdrop. Their natural-seeming movements form a fascinating contrast to their abstract forms. Unlike the mechanistic movements of the Constructivists and early Kineticists Naum Gabo and Antoine Pevsner, Calder hereby introduced living movement into geometrical abstraction.

In his motor-driven constructions, colour now played a key role. Until 1931, Calder had left his sculptural materials in their raw untreated state, and in his

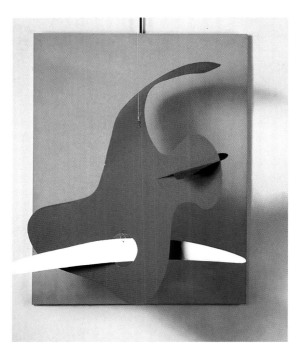

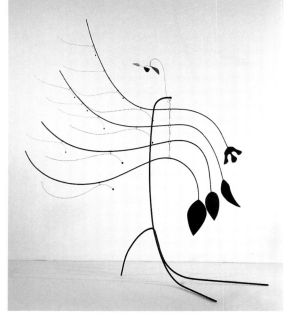

Form against Yellow, 1936
Painted sheet metal wire, steel rod and wood
122.2 x 81.6 x 77.5 cm
Washington, Hirshhorn Museum and Sculpture Garden
Smithsonian Institution, Gift of Joseph H. Hirshhorn, 1972

TOP RIGHT:
Four Leaves and Three Petals, c. 1939
Standing mobile, sheet metal, wire and paint
216.41 x 173.74 x 94.95 cm
Paris, Musée national d'art moderne
Centre Georges Pompidou

PAGE 23:
Small Blue Panel (Petit panneau bleu), c. 1936
Wood, painted sheet metal, wire, motor
35.5 x 49.1 x 43 cm
Paris, Musée national d'art moderne
Centre Georges Pompidou

graphic work, too, had limited himself to black and white contrasts. Now he used the interrelation of form and colour to dissolve volumes, creating out of such constructions a combination of flowing colour-form movements. His opting for colour, in particular for the primary colours blue, red and yellow, as well as the "non-colours" black and white, can be attributed to input from Mondrian and to his friends Miró and Léger.

The term mobile was coined by Marcel Duchamp in 1931, when he first visited Calder's rue de la Colonie studio, which the artist had taken in the same year. The painter and Dadaist object artist had already used the term "mobile" (French: movable) in 1913 to describe his first ready-made, the *Bicycle Wheel*, and since then had been experimenting with movement in his multi-facetted oeuvre. Later he produced, among other things, rotating machines that create optical illusions. The second edition of Webster's New International Dictionary from 1954 gives the following definition: mobile, a delicately balanced construction or sculpture of a type developed by Alexander Calder since 1930, usually with movable parts, which can be set in motion by currents of air or mechanically propelled. In 1955 Patrick Heron also de-

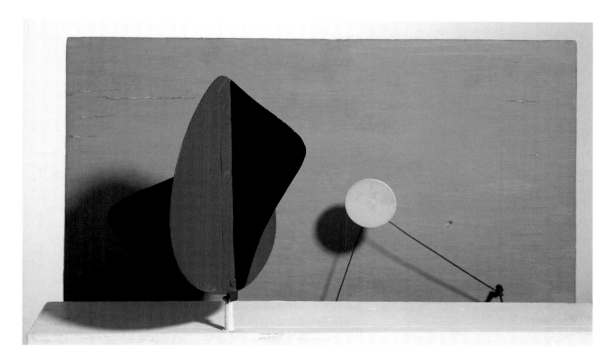

fined the mobile in his book *The Changing Forms of Art* as: "An abstract configuration of articulated parts in which each part or segment is free to describe a movement of its own; but it is a motion conditioned by, yet distinct from, the movements of all the other articulated segments of which the total construction is made up."

When the first mobiles appeared in the early 30s, they caused a sensation. For the first time in the history of art, static sculpture was freed from being "glued" to the floor, and set in motion. In their consciously technical design and disclosed construction they were still undoubtedly very much under the influence of Constructivism, especially the kinetic inventions of László Moholy-Nagy, who in the 20s had designed a light-space-modulator at the Bauhaus. With its interplay of mechanical movement and shadow projection, *The Bicycle* (1932, ill. p. 21) alludes to this pioneering achievement in kinetic art. Albert Einstein once stood in the Museum of Modern Art in New York for 40 minutes in front of one of the first mechanically-propelled mobiles of Calder and said he wished he had thought of it himself.

Calder's engineering mind was constantly being challenged. When the architect José Lluis Sert commis-

sioned him to design a work of art for the pavilion of the Spanish Republic at the Paris World Fair in 1937, Calder came up with a fountain that used mercury from the Almadén mines in south-west Spain which contained 60 per cent of the world's reserves of mercury. The place was also famous because it was here that Republican government troops had put up protracted resistance to Franco's units. So the fountain was on the one hand an expression of national pride, and on the other a symbol of resistance to Franco. Calder's *Mercury Fountain*, erected opposite Picasso's celebrated anti-war painting *Guernica*, combined technical skill with innovative design; the mobile with the static. Léger commented to the artist: "In the old days you were the wire king; now you are Father Mercury ...". This kinetic composition was one of the first of a series of fountain projects that Calder created during his life.

From 1932 onwards Calder realized his first motor-less mobiles, which were set in motion by a simple current of air. Over the years he developed three different types of mobile: those with a stand, those attached to the wall, and those which have proved the most popular – free-floating structures in different sizes, shapes and

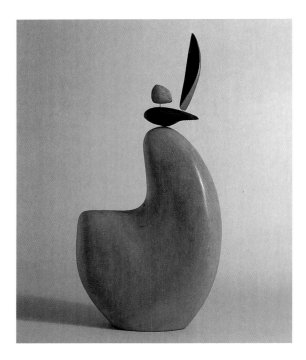

Hen, c. 1944
Wood and wire with paint, 47 x 21.6 x 9.5 cm
Private Collection
Courtesy Waddington Gallery, London

*"I try something new each time. You invent
the bracing as you go, depending on the
form of the object."*
ALEXANDER CALDER

colours that hang from the ceiling. The French art historian Michel Ragon said of them: "A Calder is a sort of chandelier, which like all chandeliers hangs from the ceiling, but which, in contrast to other chandeliers, is not used as a light fixture, but as a perch on which to rest our dreams."

The mobiles achieved perfection, however, with a technical improvement, which from 1940 on replaced the labile constructions made of rods, strings and wires. In *Hanging Spider* (c. 1940) the rods and strings are superseded by iron bars with a loop in the middle from which they hang and pieces of painted sheet metal welded on at each end. The resulting mobile has a novel organic unity, both in terms of material – it consists now exclusively of metal – and design. Calder can now "compose" movements, creating the greatest possible diversity and harmony in ensemble and sequence. Besides small toylike mobiles, Calder also designed large open-air ones, e.g. *Steel Fish* (1934). The artist invented tools too, for instance a device he used to locate the centre of gravity of his mobiles.

As already mentioned, Calder not only built mobiles but stabiles, fixed static steel constructions made of steel plates screwed or bolted or riveted together. The name "stabiles" had been invented by the sculptor Hans Arp in 1932, one year after the first Calder exhibition in Paris. Calder said of this new sculptural departure: "For my first abstract static sculptures (stabiles) I was interested mainly in space, in vectoral dimensions, and in different centres of gravity [...]. One cannot appreciate the aesthetic value of these objects when trying to reason them out. They have to become familiar to us [...]." To begin with, Calder's stabiles were filigree wire sculptures with a stable base. But as early as 1936 *Gothic Construction from Scraps* had several supporting legs and was made of sheet steel. This small filigree sculpture is regarded as a prototype for subsequent works on a larger scale. In 1937 Calder presented his mobiles and stabiles in the Galerie Pierre Matisse. The exhibition showed works from all the artist's creative periods. Here the fantastic animal forms, characteristic of his stabiles, made their first appearance. In the same year Calder constructed *Whale* for the Museum of Modern Art in New York and a year later *Spherical Triangle* (Rio de Janeiro), forerunners of the monumental stabiles of the 60s and 70s. During the 50s the stabiles completed the transition to closed flatness as well as to a more solid form in massive materials.

On 20 April 1935 Calder's first daughter Sandra was born. He bought a house in Connecticut, which he lived in when he was not in France. Calder remained enamoured of France his whole life long, spending half his time there. In 1953 he bought a farmhouse in Sache near Tours in the Loire valley. His American and French homes both lay in the depths of country, surrounded by flowers, trees and hills. Nature came to play an ever greater role in his work. He was determined that his geometrical shapes should not be seen as divorced from natural phenomena. "I think I am a realist, because I make what I see. It's only the problem of seeing it. If you can imagine a thing, conjure it up in space, then you make it and 'tout de suite' you're a realist [...]. The universe is real, but you can't see it. You have to imagine it. Once you imagine it, you can be realistic about producing it."

Calder as choreographer

The development of Calder's kinetic forms also reflects his passion for ballet and the theatre. There is a theatrical aspect to his mobiles. As in a ballet, the individual elements make their entrance, and it takes some time before the whole "performance" has been seen. The colourful, sometimes spotlit forms of the mobiles can be interpreted as metaphors for dancers, with Calder as their master choreographer. It is not surprising, therefore, that the artist repeatedly received commissions to design stage sets for contemporary dance and theatrical productions. The earliest examples are the sets for Martha Graham's ballet *Panorama* in 1935 and for Eric Satie's *Socrates*. Calder's designs in the 30s recall Bauhaus stage sets and productions, for example Oskar Schlemmer's *Triadic Ballet*. The Bauhaus artists had also experimented in the 20s with mechanical backdrops, colour, light and movement.

In 1939 Calder created a water ballet for the New York World Fair with 14 water jets, 15 metres high, that were supposed to perform various scenes and fall back into the basin with a loud bang. Although the choreography failed to work for technical reasons, a similar water ballet followed 1956 for the General Motors Technical Centre in Warren, Michigan: With this *Water Ballet*, Calder created a complex mobile out of powerful water jets. In later years, too, he designed sets for several ballet productions, including the ballet *Métaboles*, performed in 1969 at the Paris Odeon. This writer attended that show

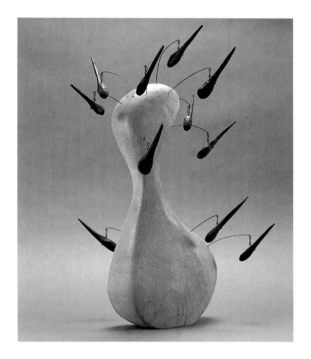

Wooden Bottle with Hairs, 1943
Wood and wire, 56.8 x 33 x 30.5 cm
New York, Whitney Museum of American Art
50th anniversary gift of the Howard and
Jean Lipman Foundation, Inc.

"About my method of work: first it's the state of mind. Elation."
ALEXANDER CALDER

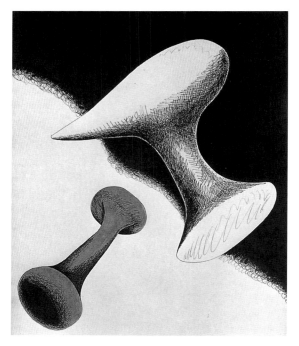
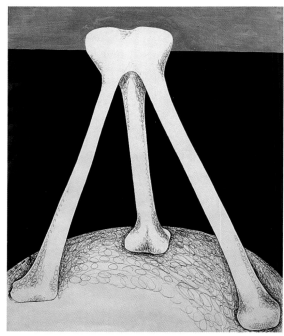

26

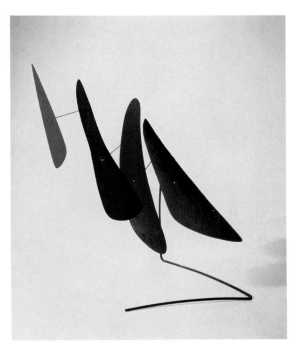

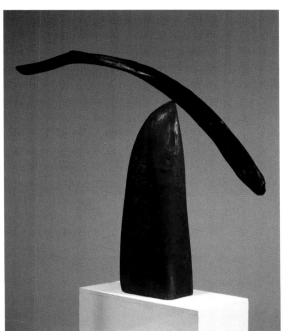

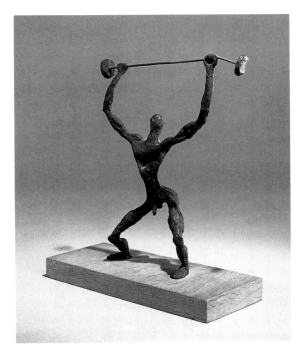

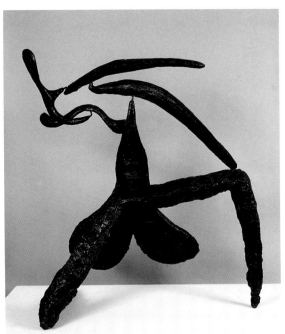

27

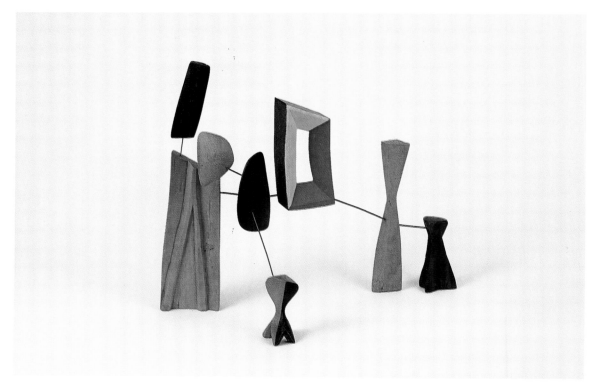

Constellation, 1943
Painted wood and wire, 37.8 x 46.4 x 20 cm
New York, Whitney Museum of American Art
50th Anniversary Gift of Howard and
Jean Lipman Foundation, Inc.
Photo: Jerry L. Thompson, New York

"I was interested in the extremely delicate
open composition."

ALEXANDER CALDER

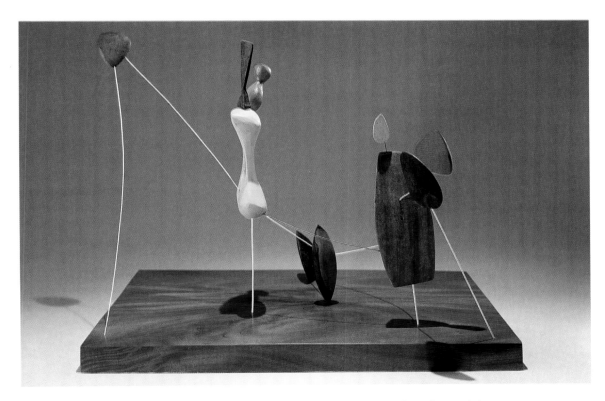

Vertical Constellation with Yellow Bone, 1943
Painted wood and wire, 57.4 x 72.5 x 65 cm
Washington, Hirshhorn Museum and
Sculpture Garden, Smithsonian Institution
Gift of Joseph H. Hirshhorn, 1972

"I also devised a new form of art consisting
of small bits of hardwood carved into
shapes and sometimes painted, between
which a definite relation was established
and maintained by fixing them on the
ends of steel wires."
ALEXANDER CALDER

PAGE 27 TOP LEFT:
Untitled, c. 1943
Standing Mobile, painted steel, 60.2 x 52 cm
Private Collection
Courtesy Gagosian Gallery, New York

PAGE 27 BOTTOM LEFT:
Haltérophile (The Weightlifter), 1930, cast in 1966
Bronze, 21.5 x 17.2 x 3.8 cm
Washington, Hirshhorn Museum and Sculpture Garden
Smithsonian Institution, Bequest of Joseph H. Hirshhorn, 1986

PAGE 27 TOP RIGHT:
Shark and Whale (Requin et baleine), c. 1933
Exotic wood, 86.5 x 102 x 16 cm
Paris, Musée national d'art moderne
Centre Georges Pompidou

PAGE 27 BOTTOM RIGHT:
On One Knee, 1944
Bronze, 96 x 94 x 91.4 cm
Private Collection
Courtesy Gagosian Gallery, New York

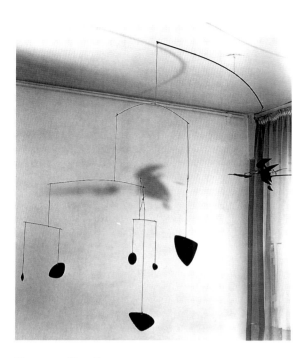

Homage to Chagall, 1944
Mobile with a goat, 115 x 110 cm
Private Collection
Courtesy Archive Ida Chagall

"To most people who look at a mobile, it's
no more than a series of flat objects that
move. To a few, though, it may be poet-
ry."

ALEXANDER CALDER

with the artist Wifredo Lam. One year before, in 1968,
Calder had put on another show, *Work in Progress*, every
aspect of which he directed himself. This production
combining mobiles and electronic music was held in the
Teatro dell' Opera in Rome and lasted a total of 19 min-
utes.

Creating jewellery
Alongside his sculptural pieces, Calder always found
time to produce jewellery. Way back in his childhood the
young Sandy had fashioned small artefacts out of wire
for his sister's dolls, decorating them with all kinds of
found objects. His mature jewellery pieces are in differ-
ent metals, sometimes even in silver or gold. Fashioned
out of wire, these abstract or figurative pieces often
contain "jewels" made out of semi-precious stones or
of coloured ornamental glass. For his wife Louisa he
crafted a gold engagement ring, while for friends he
made copper wire wedding rings or aluminium pins in
the shape of a hand. One of the more low-key branches
of Calder's overall work is his kinetic jewellery – earrings
in the form of miniature mobiles, bracelets with mobile
parts, or necklaces made out of spirals, which oscillate
with every movement. Although Calder showed his jew-
ellery in some exhibitions, he did not permit its commer-
cial reproduction. Such pieces remained for him small
unique works of art.

Breakthrough to world fame
In September 1943 Calder was accorded a retrospective
of over 80 works in New York's Museum of Modern Art.
He was the youngest artist ever to be so honoured. After
the exhibition he became the best-known contemporary
sculptor on both sides of the Atlantic. As America be-
came drawn more and more deeply into the Second
World War, Calder's vibrant art seems to have served as
a way of relaxing and cheering people up. His humour
and optimism were an effective remedy against depres-
sion and despair. Calder amused his audience with his
effervescent spirit and great inventiveness. *The Art Digest*
of 1 October 1943 writes of his New York exhibition:
"Not one of the almost a hundred exhibits is lacking in
verve or humour; they brim with imaginativeness and
the unexpected. In some of his largest mobiles, with
their bravura deployment of giant branches of black
sheet-steel, Calder reaches the pinnacles of graphic de-
sign [...]."

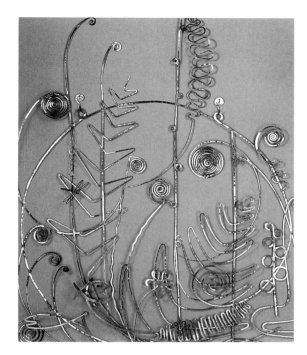

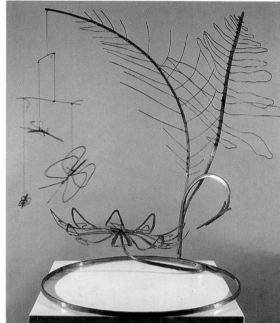

Silver Bed Head (commissioned by Peggy Guggenheim),
1945–46
The two fishes (lower left) and the dragon fly (upper left)
are mobile. Peggy Guggenheim hung this major piece over
her bed at the Palazzo Venier dei Leoni in Venice
Silver, 160 x 131 cm
Venice, Peggy Guggenheim Collection
© 1998 The Solomon R. Guggenheim Foundation

TOP RIGHT:
Calderoulette, c. 1947
Brass with nylon thread, H 51.4 cm
Private Collection
Courtesy Harriet Griffin, New York

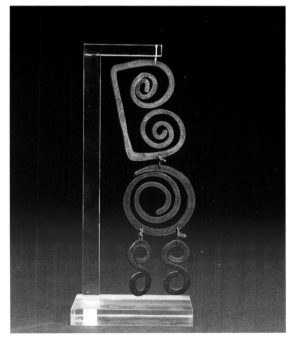

BOTTOM:
BOSS (ornament), no date
Hammered brass and silver, H 15 cm
Private Collection
Courtesy Christie's, New York

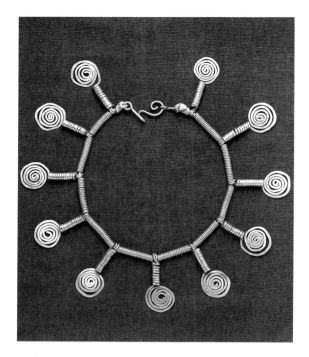

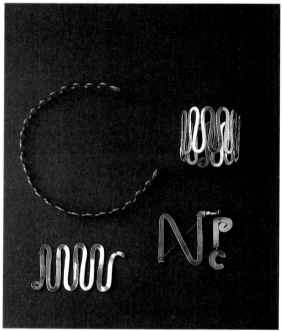

Necklace, c. 1940
Brass and cord, 25.7 x 25.7 x 6 cm
New York, Whitney Museum of American Art
Gift of Scultotec Inc.

PAGE 33 TOP:
Choker, 1948–50
Gold-plated silver wire
Private Collection
Courtesy Christie's, New York

PAGE 33 BOTTOM LEFT:
Necklace, c. 1940
Hammered silver and silver wire
Overall: 47.6 x 33 x 1 cm
New York, Whitney Museum of American Art
Gift of Mr and Mrs Marcel Breuer

PAGE 33 BOTTOM RIGHT:
Necklace, 1949
Silver, L 44.5 cm
Private Collection
Courtesy Christie's, New York

TOP RIGHT:
Alice Band, c. 1940
Brass, H 1.5 cm
Private Collection
Courtesy Maître Francis Briest, Paris

Bracelet, c. 1940
Silver, H 5 cm
Private Collection
Courtesy Maître Francis Briest, Paris

Belt Buckle, 1953
Silver, H 5 cm
Private Collection
Courtesy Maître Francis Briest, Paris

Brooch, c. 1940
Mobile, silver, H 5.5 cm
Private Collection
Courtesy Maître Francis Briest, Paris

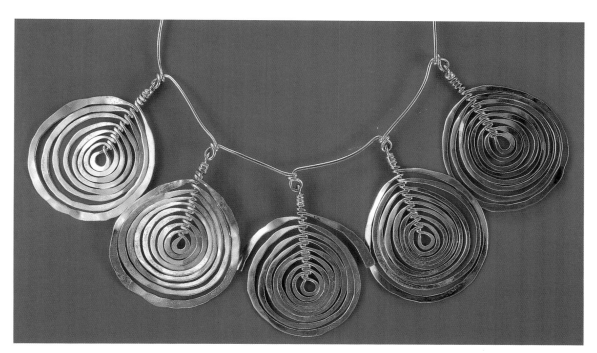

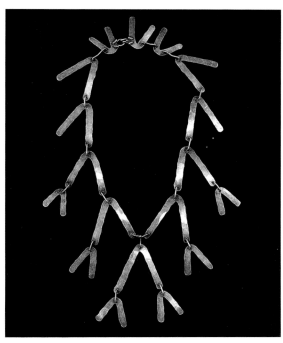

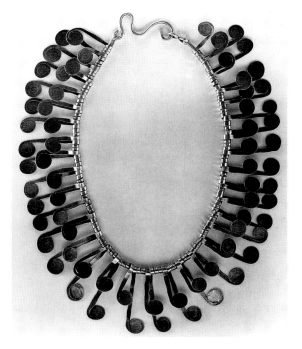

33

The Yellow Tights, 1945
Gouache on paper, 56 x 46 cm
Washington, Hirshhorn Museum and Sculpture Garden
Smithsonian Institution, Gift of Joseph H. Hirshhorn, 1972

"I did some large human heads with stripes. I seemed to develop something new."

<div align="right">ALEXANDER CALDER</div>

"A mobile is a little private celebration."

<div align="right">JEAN-PAUL SARTRE</div>

Although Calder's creations sometimes had a menacing aspect – his stabiles of the mid-40s took the form of strange-looking creatures – his work did not change significantly over the war years. Later the artist recalled, above all, the shortage of materials caused by the war, which compelled him to resort to unusual measures. Thus in 1943, for instance, he broke up his aluminium boat to create various objects out of it. The same year saw him produce his *Constellations* (ill.p. 28–29), small biomorphic pieces of wood joined together with wire and partially painted. In the late 30s Miró had created a series of works with the same title, linking dense patterns of multicoloured biomorphs with black lines. But Calder's *Constellations* are also reminiscent of the idiom of Hans Arp's wooden reliefs and of Yves Tanguy's surrealist abstractions. During the early years of the war Calder became friends with Tanguy and his wife, the painter Kay Sage. Emigrants from Paris, they had acquired a house in Woodbury, Connecticut, and frequently visited the Calders in their home in Roxbury. In 1943 the Pierre Matisse Gallery in New York mounted a joint exhibition of Calder's *Constellations* and Tanguy's paintings.

Another artist in exile in the USA was Marc Chagall, who had temporarily arrived with his wife Bella in 1941. The Chagalls stayed regularly in Preston, Connecticut, where the Calders got to know them. In 1944 the sculptor produced a mobile with a flying goat (ill. p. 30), which was a homage to Chagall's art. The mid-40s was also the time when Calder did his colourful gouaches, first exhibited in 1945 in the Kootz Gallery. The *Art Digest* carried a report on the show: "Alexander Calder's glowing gouaches dominate the gallery walls with reds, yellows and blacks [...]. Besides the powerful colour fields, line also plays an important role. [...] they [the gouaches] reveal him [Calder] to be a possible rival to the likes of Klee or Miró [...]. Large black elliptical forms appear on many of the exhibits, alongside circular swirls of the kind used in portrait studies." Gouaches continued to be a constant companion to his other work, making a welcome change from workshop production. During a subsequent exhibition of the gouaches in the Parisian Galerie Maeght, Sonia Delaunay once said to the author: "Do you know that Calder with the primary colours in his gouaches was influenced by us two [Sonia and Robert Delaunay]?" They both admired Calder's work.

In 1946, with the war at an end, Calder returned to France where he illustrated the *Fables of La Fontaine*. In

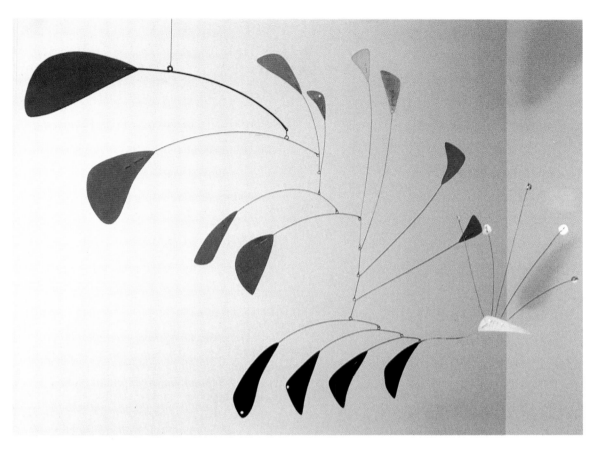

Untitled (Peacock), 1941
Painted metal and unpainted aluminium
with twenty elements
Mobile; Span: 125.7 cm; Drop: 93.3 cm
Private Collection, former Collection of Jean-Paul Sartre
Courtesy R. Kaller-Kimche Inc., New York

LEFT:
Jean-Paul Sartre with Cigarette, 1947
Drawing, ink, 15.2 x 11.4 cm
Private Collection

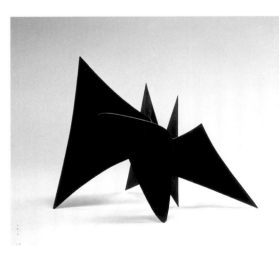

Paris he had an exhibition of his mobiles in the Galerie Louis Carré, and one of the first visitors was the artist Henri Matisse. The existentialist philosopher Jean-Paul Sartre, in his text for the catalogue, was full of praise: "The 'mobiles' [...] are neither wholly living nor wholly mechanical [...]. I know of no art which is less deceitful than his." In 1947 Calder was involved in a joint exhibition with Léger at the Stedelijk in Amsterdam. A year later the Brazilian architect H. Mindlin wrote: "Calder's works show more than just the youthful inventive American spirit. Their humour, their instability, their accidental quality also betrays the anxieties of our era. And the subtle elusive lyricism of his forms bespeaks our disillusionment with the obvious and explicit."

The economic resurgence after the war brought Calder a number of major commissions for mobiles in public buildings. Traditional figural sculpture did not seem right for the new international building style. Instead giant colourful mobiles now filled the entrance halls and lobbies of airport terminals, public plazas and company headquarters. The large-scale mobiles commissioned by Calder's corporate clients far exceeded the small-scale models he was capable of producing in his Roxbury workshop, and so he had them constructed in various local Connecticut metal shops, in Waterbury and Watertown. In 1949 the sculptor created his largest mobile yet, the *International Mobile* (609.6 x 609.6 cm), exhibited in the Philadelphia Museum of Art. This was later bought by the Houston Museum of Fine Arts in Texas.

From 1951 onwards, two new series enriched the Calder œuvre – the Gongs and Towers. The "Gongs" revisit his early experiments with sound, as their metal elements are set chiming by the wind. The "Towers" are architectural constructions: Small mobiles or floating individual parts hanging in an open wire scaffold (e.g. *Bifurcated Tower*, 1950, ill. p. 36). These works fuse traditional biomorphic forms with earlier constructivist tendencies and are reminiscent of the monuments of the Russian Constructivists Vladimir Tatlin and Naum Gabo. One commission was especially in keeping with the events of the time: Calder was asked to contribute to Henri Pichette's play *Nucléa*, which horrifically dramatised the threat of nuclear war and which was staged by Jean Vilar at Paris' Théâtre National Populaire in spring 1952. Giant mobiles hung like menacing clouds from the ceiling, while tower-like stabiles with lively projections symbolised the machinery of war. Two years later, at the

request of the Venezuelan architect Carlos Raul Villanueva, Calder constructed an acoustic ceiling for the main hall of the University of Caracas.

In the summer of 1952 Calder was chosen to represent the USA at the Venice Biennale, where he won first prize for sculpture. In 1955 he undertook a three-month trip to India, where he produced some works and had an exhibition in Bombay. The year 1956 marked the beginning of a long collaboration with the Perls Gallery in New York, which mounted no fewer than 18 exhibitions of the artist. Now commercial success was not long in coming for the sculptor. In 1958 Calder was awarded the prestigious Carnegie Prize and asked to create a huge hanging mobile for the Carnegie Institute in Pittsburgh. For the 1958 World Fair in Brussels he realised the work *Whirling Ear*, a mechanically driven sculpture made of black-painted aluminium and steel that was installed on a water surface. It was some 6 metres high and built from a twelve-inch model. That same year Calder also completed a gigantic mobile for the arrival hall of New York's John F. Kennedy airport and the enormous stabile-mobile *Spiral* (ill. p. 41) for the headquarters of UNESCO in Paris.

Monumental late work
Calder's stabiles or stabile-mobiles (an intermediate form between mobile and stabile) are to be found in numerous public places throughout the world. They are often huge constructions made of heavy plates of sheet-steel painted black or red, and as such seem to be the opposite of Calder's idea of a mobile and movable art work. And yet the stabiles still produce some kinetic effects. In spite of their material weight, the massive steel plates radiate dynamic lightness. These stabiles are "dream satellites made of metal, forged with an engineer's precision and formed with a poet's sensibility and intensity" (Peter Bellew).

The gigantic stabiles of the 60s and 70s often depict fantastic birds, dinosaurs or other monster creatures. *Longnose* of 1957 looks like a bird that has either just alighted or is about to fly off. The 1974 *Flamingo* (ill. p. 90) in red-painted steel soars more than 16 metres high over Chicago's Federal Centre Plaza. The sweeping movement of its two long stilt-like legs is clearly modelled on a bird. In Spoleto (Umbria) Calder realized one of his largest and most impressive stabiles. This huge work from 1962 (15 metres high), titled *Teodelapio* (ill.

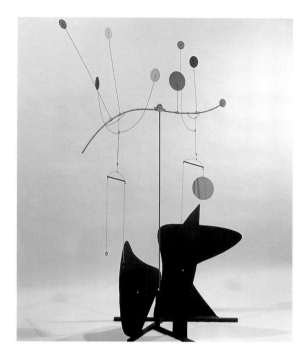

Black Tulip, c. 1942
Standing mobile, painted metal, 198 x 124.4 x 99 cm
Private Collection
Courtesy Richard Gray Gallery, Chicago

PAGE 36 TOP:
Bifurcated Tower, 1950
Painted metal, wire and wood, 147.3 x 182.9 x 134.6 cm
New York, Whitney Museum of American Art
Purchased with funds from the Howard and Jean Lipman Foundation, Inc.
Photo: Jerry L. Thompson, New York

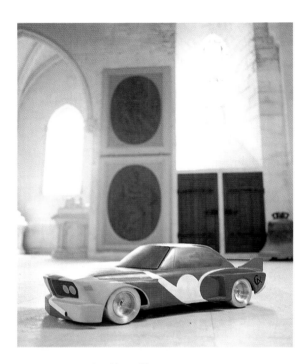

BMW 3 OCSL, painted by Calder, 1975
Original maquette, painted with oils
Private Collection
Courtesy Maître Francis Briest, Paris

"You should know how to get the best out
of leisure; it's a stimulating atmosphere
for invention."
ALEXANDER CALDER

PAGE 39:
Fafnir – Dragon II, 1969
Painted Steel, 3.25 x 4.1 m
Private Collection

p. 85), rears up like a primordial beast towering over the traffic driving underneath it.

In 1964 Calder exhibited five stabiles at *documenta III* in Kassel. At the end of the same year the Guggenheim Museum devoted a retrospective to Calder, showing 361 works. The venue seemed almost too small for all the pieces of his late work, but the Museum's round spiralling construction was as if made for *The Ghost*, a colossal mobile that Calder designed specially for the exhibition. $10^1/_2$ metres long, it hung down from the ceiling into the rotunda, and demonstrated once again just how effective and intriguing Calder's art works are in the public domain. Years earlier, when the architect Frank Lloyd Wright, who designed the Guggenheim Museum, found out that Calder was creating a monumental mobile for his building, he conveyed his wish that it should be in gold. Without a moment's hesitation Calder sent word back "I'll do it in gold, but I'll paint it black."

During the 60s his stabiles grew even higher. In 1965 a large Calder stabile was installed in the Lincoln Centre in New York, and two years later, at the World Fair in Montreal, the sculptor realized his tallest stabile thus far, *Man*, which was 23 metres high. The 24-metre-high stabile *El Sol Rojo (Red Sun)* was erected in the Olympic stadium in Mexico on the occasion of the 19th summer games. The hanging motor-propelled mobile *Red, Black and Blue* for Dallas airport stretched to a width of 14 metres. In 1969 he made the impressive stabile *La Grande Vitesse* (ill. p. 87) for Grand Rapids, a town in Michigan.

Calder's *Universe* (ill. p. 49), installed in 1974 in Chicago's Sears Tower, seems like a summation of his work. Seven motors drive different coloured elements against the background of a large coloured wall – a brilliant kinetic installation that seems to recall his early motorised abstract constructions, yet which also wonderfully expresses the freshness and lightness of touch of the late Calder. In 1976 the sculptor designed the monumental *Jerusalem Stabile* (ill. p. 91), which was dedicated after his death the same year to the citizens of Jerusalem. Calder did not live to see the installation of his last gigantic stabile-mobile, *Mountains and Clouds*, planned since early 1976, which was installed in the U. S. Senate Office Building in Washington.

Almost a logical consequence of Calder's urge to monumentalise his art was the 1973 commission by Braniff International Airlines to paint three airplanes

(ill. p. 82–83). He also painted various cars, including a BMW (ill. p. 38).

Calder's last monumental stabiles were the most sculptural pieces in his entire oeuvre. For each one, he made a maquette which was later enlarged under his close supervision. With their static permanence, they alone paid homage to his father and grandfather.

Calder's Universe

In October 1976 the Whitney Museum in New York opened a major retrospective of Calder's works representing every phase and aspect of his oeuvre. The title of the show was *Calder's Universe*. A short time later, on 11 November 1976, Calder died unexpectedly from a heart attack. The Whitney exhibition became a living memorial to him. Tributes began flowing in to this truly unique artist who through his art had brought joy and fun to so many people all over the world.

President Gerald Ford said: "Art has lost a great genius and the United States has lost a great American, who has contributed much to the civilisation of the 20th century." The sculptor Henry Moore said: "Though our work was very different, he was so wonderfully innovative [...] his work was so gay and happy, full of the happiness of life." And Louise Nevelson, another great American sculptor was of the opinion: "Calder was an original, an outstanding creative mind of the 20th century." William Rubin of the Museum of Modern Art wrote:

"Calder was the first American modernist working in any medium to impose himself on the history of art as an artist of worldwide importance, and to be universally recognized as such." The art critic Emily Genauer said: "Underneath all the fun and games is one of the most innovative sculptural minds of the 20th century." And the art historian James Johnson Sweeney, mentor and staunch advocate of Calder, made the very personal eulogy: "We will miss his dancing and his gruff sleepy-bear character, as well as his eternal red shirt, so symbolic of his personal warmth. But the sense of rhythm, the sense of fun and the capacity for enjoyment, which were essential elements of his life as well as his art, will remain always for us who knew him."

Calder was indeed gregarious, he loved to laugh and tell jokes. He was never solitary, but radiant and exuberant, exuding great warmth. His imagination was dazzling, and his creations full of gaiety, humour and poetry. He was called the "Mozart of space" and gave pleasure to people, radiating a joyous zest for life beyond rigid art dogmatism and cryptic symbolism. Above all he was a deeply compassionate man – a good citizen, always concerned with world problems. In his work – a triumph of human spirit over technology – he combined his international and European experience with American ingenuity. He was admired and beloved the world over, and recognised as one of the few real leaders whose ideas revitalised the art of the 20th century.

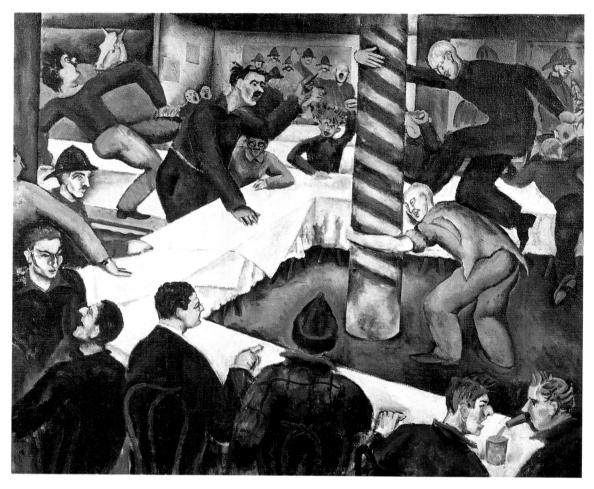

Firemen's Dinner for Brancusi, 1926
Oil on canvas, 91.4 x 106.7 cm
New York, Whitney Museum of American Art
Gift of the artist

PAGE 43 TOP LEFT:
Blossom, 1947
Oil on canvas, 91.4 x 61 cm
Courtesy O'Hara Gallery, New York

PAGE 43 TOP RIGHT:
Twisting Form, 1963
Oil on canvas, 115 x 88.9 cm
Collection José Mugrabi, New York

PAGE 43 BOTTOM LEFT:
Untitled, c. 1950
Oil on canvas, 116 x 88.9 cm
Private Collection
Photo: AKG Berlin

PAGE 43 BOTTOM RIGHT:
Untitled, c. 1945
Oil on canvas, 40.64 x 30.8 cm
Courtesy O'Hara Gallery, New York

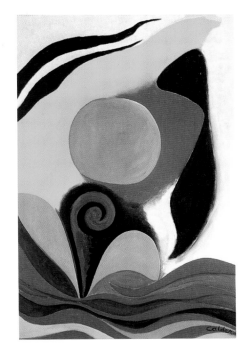

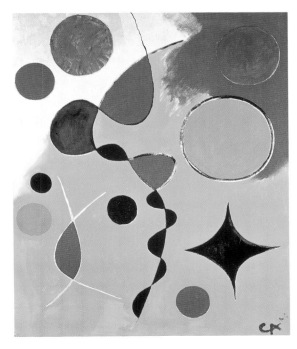

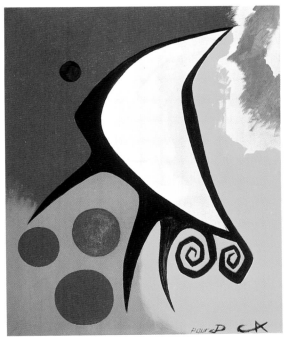

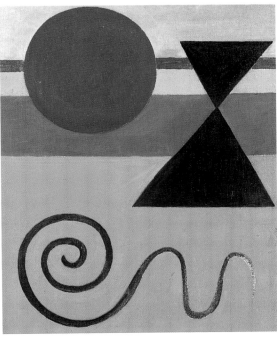

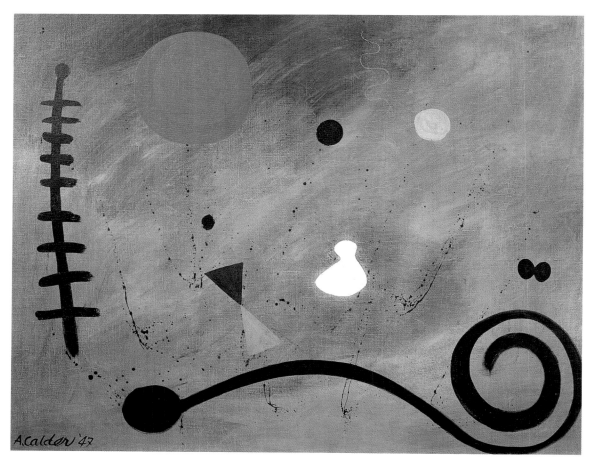

Surrealist Composition, 1947
Oil on canvas, 63.5 x 76 cm
Private Collection, New York

"Calder became more and more sympa-
thetic to Arp, whom he knew from
Abstraction-Création, and Miró, and
gradually introduced biomorphic forms,
which he added to his geometric forms."
BERNICE ROSE
former curator of the Museum of
Modern Art, New York

Fond clair, 1949
Oil on canvas, 122 x 152 cm
Private Collection
Courtesy Galerie Fabien Boulakia, Paris

"In the Abstraction-Création group were
many of Sandy's new friends, serious
artists searching for new forms of expres-
sion. ... Mondrian, Hélion, and Miró
seem to have most directly influenced
Sandy's thinking, but he soon worked
out his own ideas, his own style and
idiom."

MARGARET CALDER HAYES
Calder's sister

45

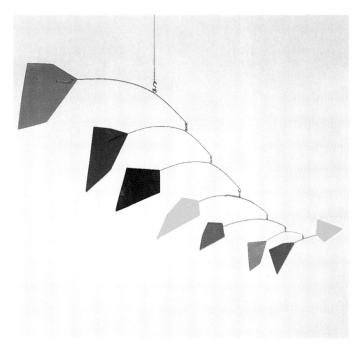

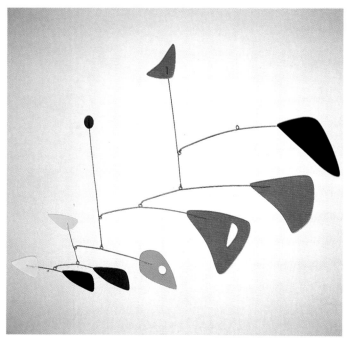

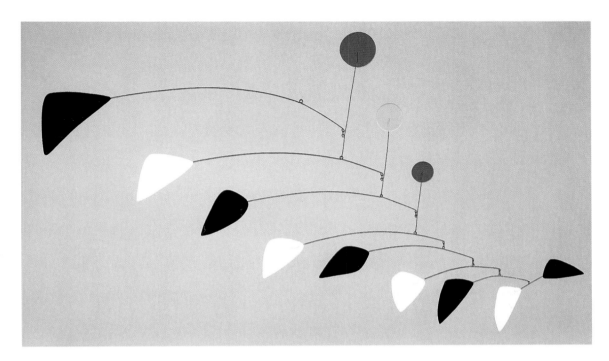

Three Discs in the Air, 1967
Hanging mobile, painted metal, 100 x 170 cm
Private Collection
Courtesy Waddington Gallery, London
Photo: Prudence Cuming Associates Ltd., London

"A mobile is an abstract sculpture made
 chiefly out of sheet metal, steel rods, wire,
 and wood. Some or all of these elements
 move, propelled by electric motors, wind,
 water or by hand."

"When everything goes right a mobile is a
 piece of poetry that danced with the joy of
 life and surprised."

"Why must art be static? The next step is
 sculpture in motion."
 ALEXANDER CALDER

PAGE 46 TOP:
Eight Polygons, 1973
Hanging mobile, painted metal, 56 x 103 cm
Private Collection
Courtesy Deborah Ronnen Fine Arts, Rochester (NY)

PAGE 46 BOTTOM:
Untitled, 1952–53
Maquette for the Palais de Chaillot
Hanging mobile, painted metal, 94 cm
Private Collection
Courtesy Gagosian Gallery, New York

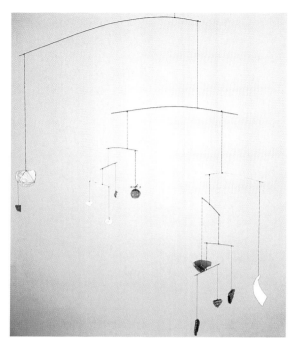

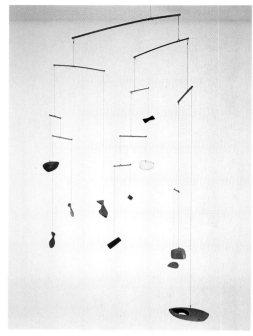

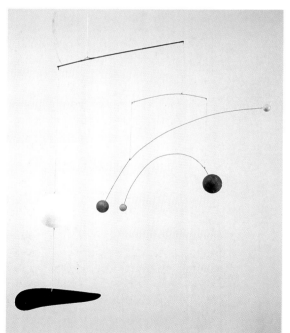

TOP LEFT:
Untitled, c. 1949
Mobile, glass, metal, porcelain, shell and string
H c. 90 cm
Courtesy Davlyn Gallery, New York

TOP RIGHT:
Untitled, no date
Mobile, carved and painted wood (11 elements)
218.5 x 157.5 x 11.5 cm
Private Collection, Rochester (NY)

BOTTOM:
Untitled, c. 1938
Mobile, painted wood, c. 80 cm
Private Collection

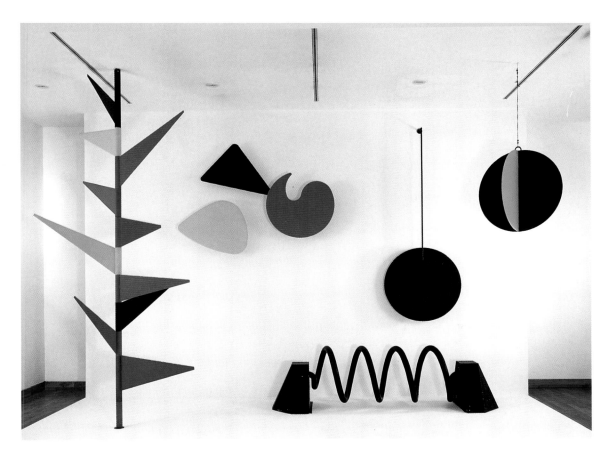

The Universe, 1974
Maquette for the monumental mobile in Chicago, Sears Tower
Mechanized mobile, painted sheet metal, 366 x 549 x 213 cm
Private Collection
Courtesy Waddington Gallery, London

"The underlying sense of form in my work has been the system of the universe."

"With a mechanical drive, you can control the thing like the choreography in a ballet."

"Disparity in form, color, size, weight, motion, is what makes a composition."

"Each element can move, shift, or sway back and forth in a changing relation to each of the other elements in the universe. Thus they reveal not only isolated moments, but physical law or variation, among the events of life. Not extractions, but abstractions,"
ALEXANDER CALDER

49

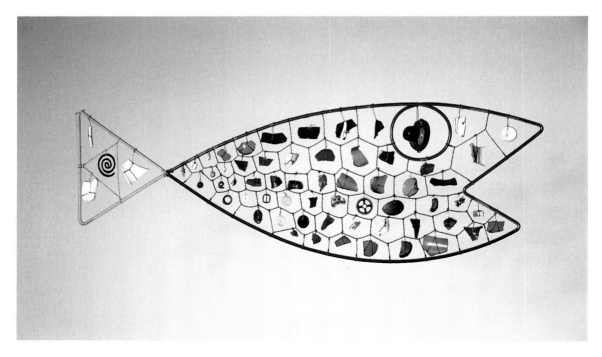

Fish, 1945
Painted metal rod, wire, metal, plastic, wood,
glass and ceramic fragments, 41.2 x 122 x 10 cm
Washington, Hirshhorn Museum and Sculpture Garden
Smithsonian Institution, Gift of Joseph H. Hirshhorn, 1966

"I feel an artist should go about his work simply with great respect for his materials."

"A mobile is a very modest thing."

"Sculpture should appear free of gravity and should be able to move; solid sculptural form may be flat, but all sculpture should be painted; and whether scintillating or solemn, sculpture must be a joy to look at."

ALEXANDER CALDER

PAGE 51:
Chock, 1972
Metal assemblage, 71 x 54.6 x 67.3 cm
New York, Whitney Museum of American Art
Gift of the artist
Photo: Geoffrey Clements

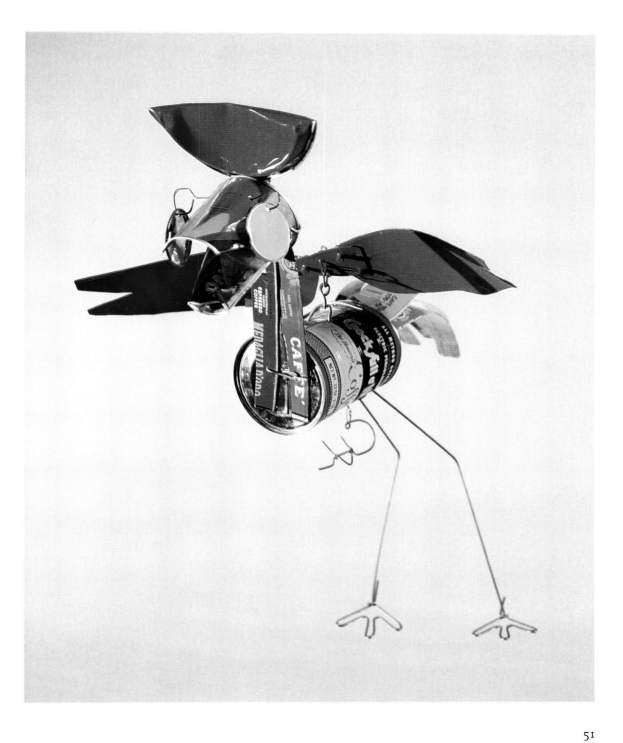

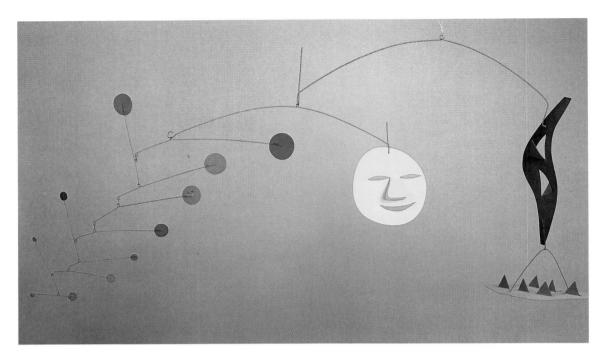

Flames and Moon Face, 1975
Printed sheet metal and steel, H 66 cm, W 170.2 cm
Private Collection
Courtesy Waddington Gallery, London

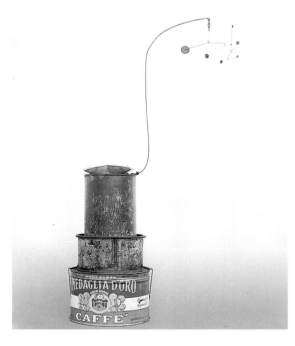

PAGE 53:
Fish with Human Head (Poisson avec tête humaine), 1976
Hanging mobile, painted metal
Overall: 134.6 x 73.7 x 73.7 cm
Private Collection

LEFT:
Ashtray with Mobile for Saul Steinberg, c. 1951
Tin cans and metal, H 71 cm
Collection Saul Steinberg, New York

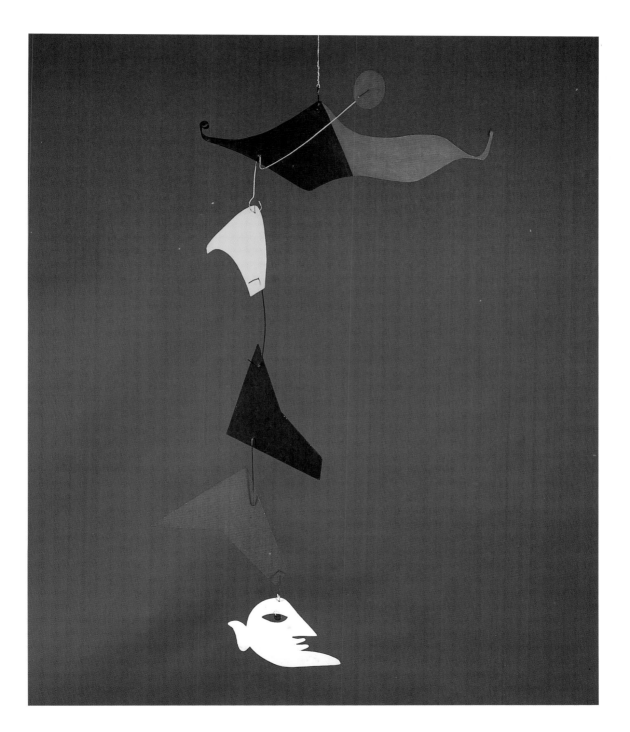

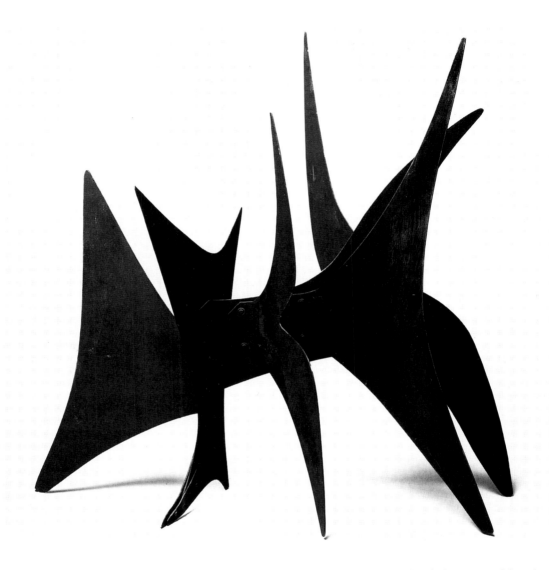

La Botte, c. 1959
Stabile (maquette), 46 x 48 x 26 cm
Private Collection
Courtesy Waddington Gallery, London

PAGE 55:
Untitled, c. 1947
Stabile, painted metal, H 83.8 cm
Private Collection
Courtesy Gagosian Gallery, New York

"I make a little maquette of sheet alumin-
ium. With that I'm free to add a piece, or
to make a cutout. When the enlargement
is finished, I add the ribs and the gus-
sets."

ALEXANDER CALDER

54

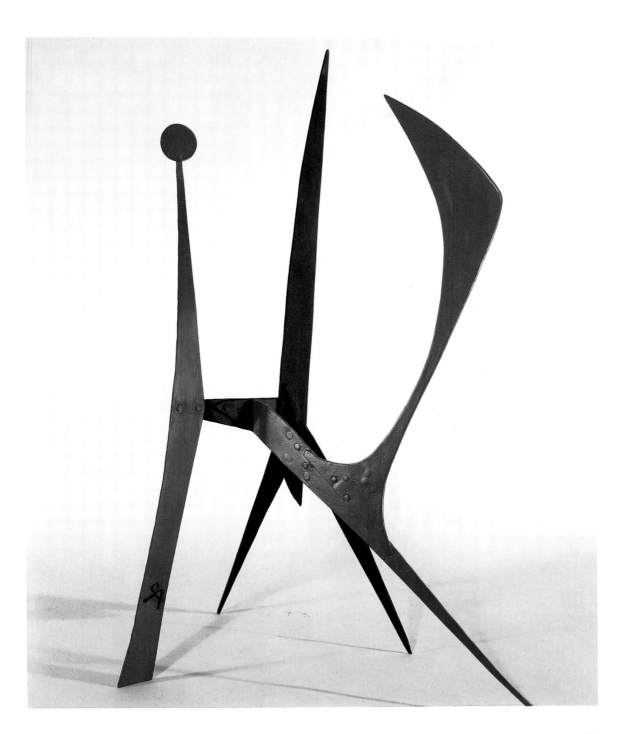

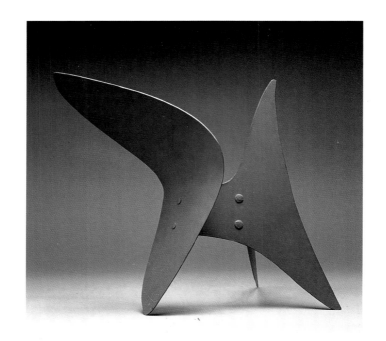

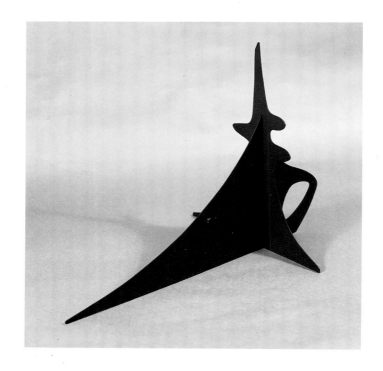

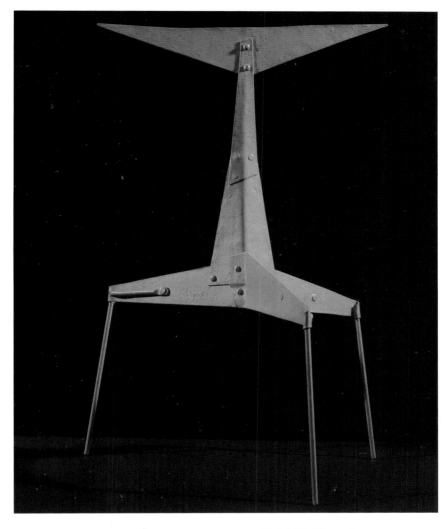

PAGE 56 TOP:
Curved Plough, c. 1960
Stabile (maquette), painted metal
Overall: 35.5 x 38 x 35.5 cm
Collection José Mugrabi, New York

PAGE 56 BOTTOM:
The Nose, 1968
Stabile (maquette), 31.5 x 46 x 28 cm
Private Collection
Courtesy James Goodman Gallery, New York

Model T Stabile, 1946
Stabile, red-painted metal, 62 x 46 cm
Private Collection

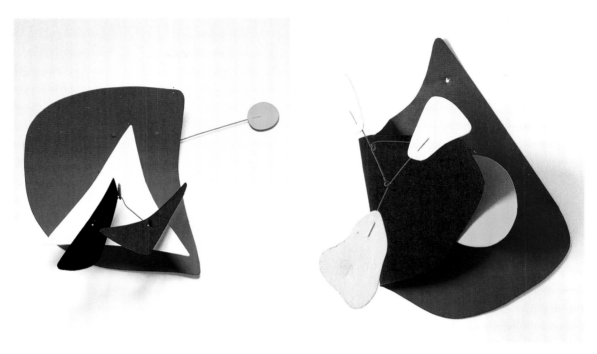

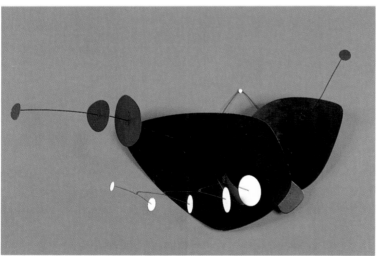

TOP LEFT:
Fond Rouge, 1972
Wall mobile, painted metal
61 x 83.8 x 52 cm
Courtesy Davlyn Gallery, New York

TOP RIGHT:
Escutcheon, 1976
Wall relief, painted metal
63.5 x 43.2 x 25.4 cm
Private Collection
Courtesy Waddington Gallery, London

Escudo (Shield), 1955
Wall mobile, painted sheet metal and wire
47 x 62.2 x 97.4 cm
Private Collection
Courtesy James Goodman Gallery, New York

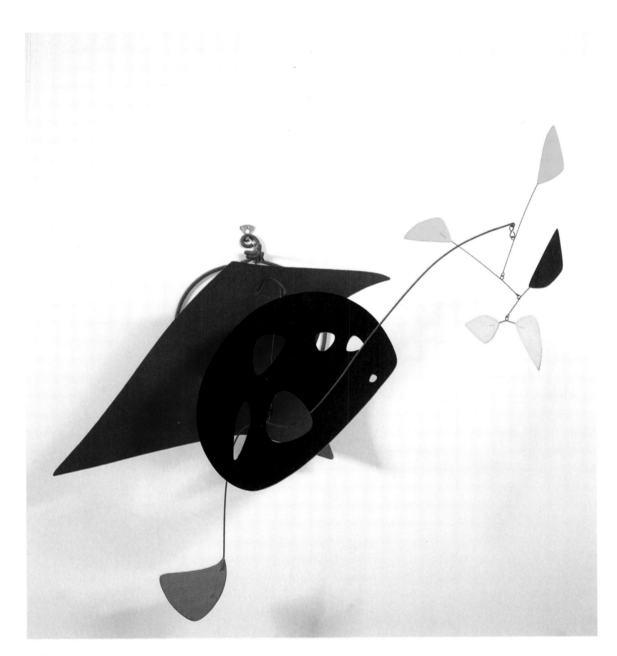

Black Sponge, c. 1957
Hanging wall mobile
Private Collection
Courtesy Harriet Griffin, New York

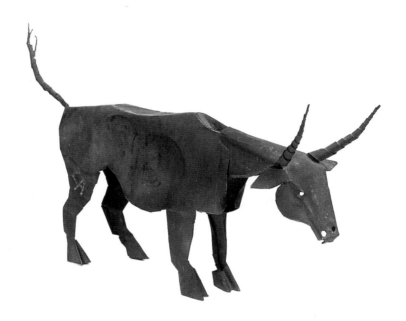

TOP:
Old Bull, 1930
Sheet brass, 26.7 x 50.8 x 11.4 cm
New York, Whitney Museum of American Art
Purchased with funds from the Howard and
Jean Lipman Foundation, Inc.

PAGE 61:
The Cow (La Vache), 1975
Stabile, sheet metal, painted red
80 x 182.9 x 71.2 cm
Private Collection
Courtesy Christie's, New York

"The cow is a languid, long-suffering animal."

"I seem to remember animals rather well, I used to draw them in the Central Park Zoo."

ALEXANDER CALDER

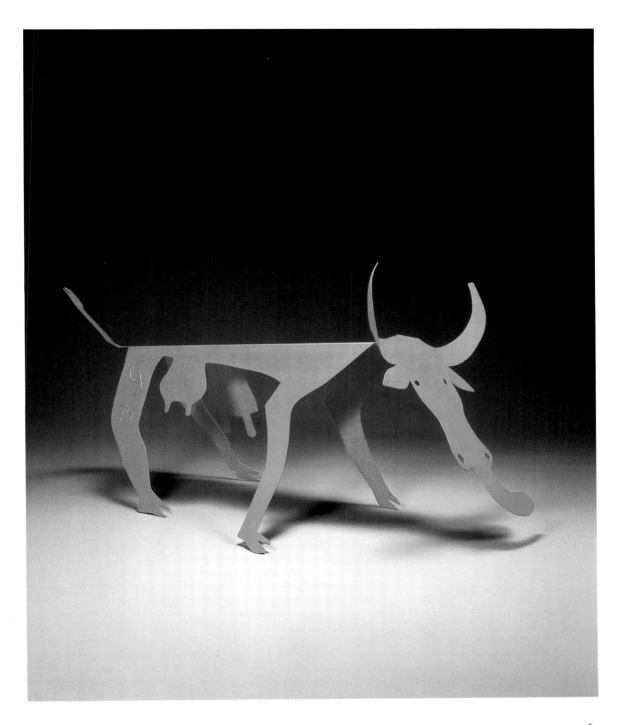

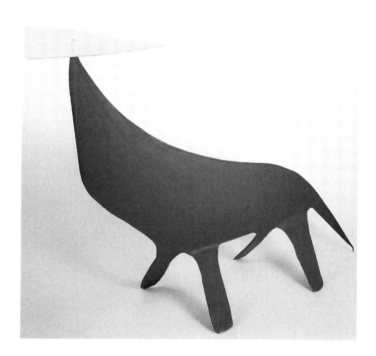

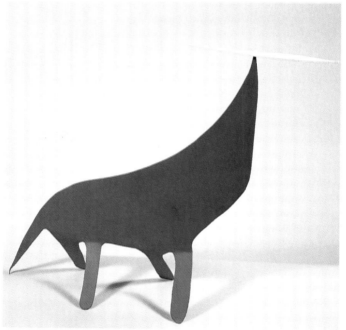

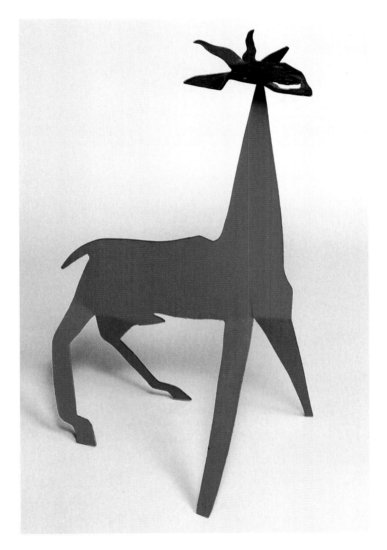

PAGE 62 TOP:
Red Bull, 1971
Animobile, painted metal, 60.3 x 74.9 cm
Private Collection
Courtesy Gagosian Gallery, New York

PAGE 62 BOTTOM:
Blue Bull, 1970
Animobile, painted metal, 60 x 75 cm
Private Collection
Courtesy Waddington Gallery, London

Black-Headed Goat, 1971
Animobile, painted metal
81.3 x 49.5 x 35.6 cm
Private Collection
Courtesy Waddington Gallery, London

63

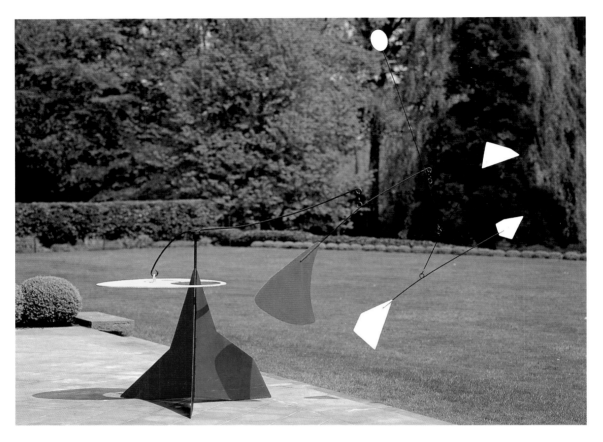

Yellow Disc, 1953
Stabile-mobile (5 elements), 271 x 288 x 110 cm
Courtesy Galerie Hans Mayer, Düsseldorf

*"The round white disc is pretty much a
standard thing in life – snowflakes,
money, bubbles, cooking devices."*

*"Why not plastic forms in motion? Not a
simple translatory or rotary motion but
several motions of different types, speeds
and amplitudes composing to make a
resultant whole. Just as one can compose
colors, or forms, so one can compose
motions."*

ALEXANDER CALDER

PAGE 65:
Twenty-three Snowflakes, 1975
Stabile-mobile, sheet metal, metal rod, wire
118 x 134.6 cm
Private Collection
Courtesy Waddington Gallery, London

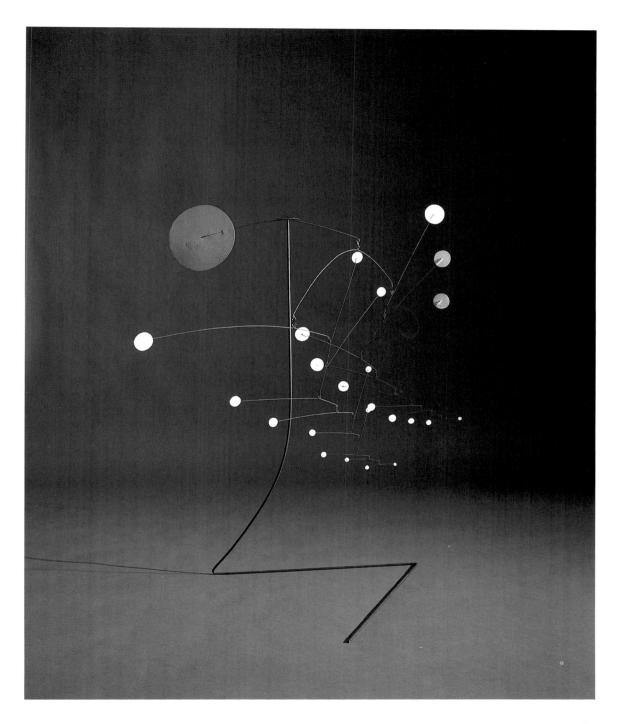

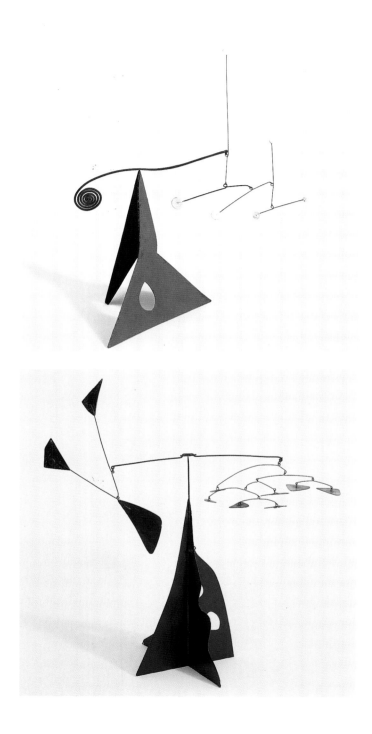

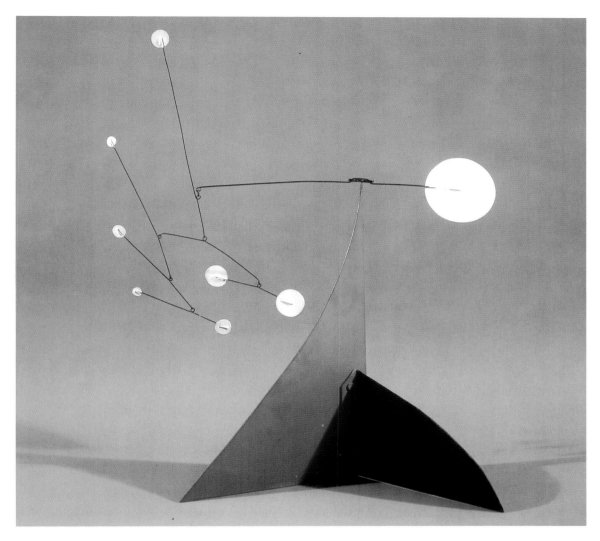

PAGE 66 TOP:
Untitled, c. 1950
Standing mobile, painted metal, 27.9 x 25.4 x 15.2 cm
Collection José Mugrabi, New York

PAGE 66 BOTTOM:
Untitled, c. 1948
Standing mobile, painted metal, 36 x 53.3 x 38 cm
Collection José Mugrabi, New York

White Disc, Seven Dots on Red and Black, 1960
Standing mobile, painted sheet metal and sheet wire
54.3 x 55 x 60 cm
Courtesy The Elkon Gallery Inc., New York

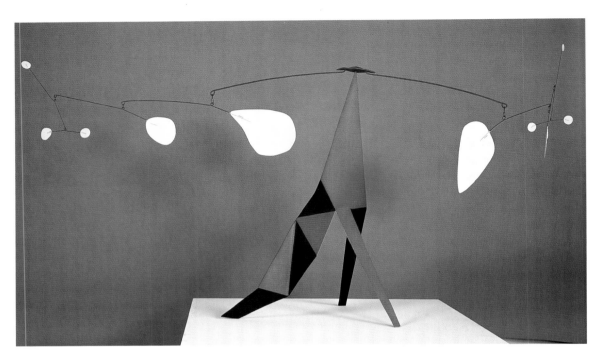

The Snowy Peak, 1969
Stabile-mobile, painted metal and wire
92.7 x 162.6 x 81.3 cm
Private Collection
Courtesy Waddington Gallery, London

Mobiles at the top
Stabiles at the bottom
Such is the Eiffel Tower
Calder is like the Tower

Iron bird catcher
Watchmaker attuned by the wind
Tamer of black beasts
Hilarious engineer
Restless architect
Sculptor of time
This is Calder

JACQUES PRÉVERT

PAGE 69:
Crag with Petals and Yellow Cascade, 1974
Standing mobile, painted sheet metal and rod
196 x 202 x 155 cm
Courtesy Davlyn Gallery, New York

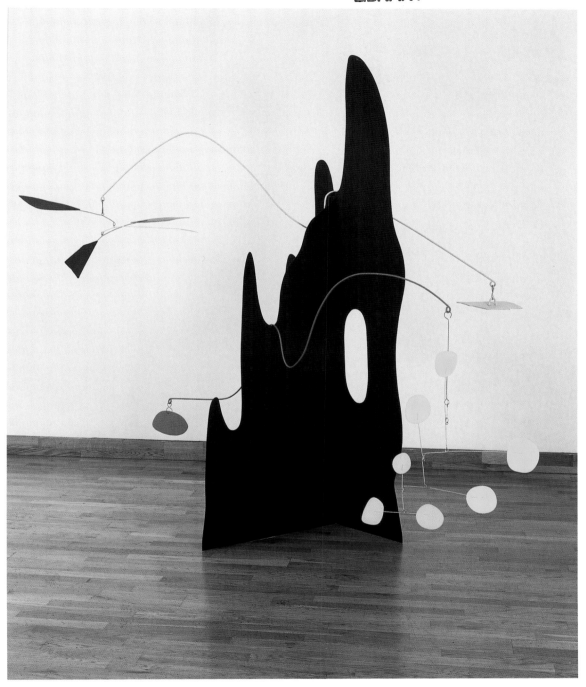

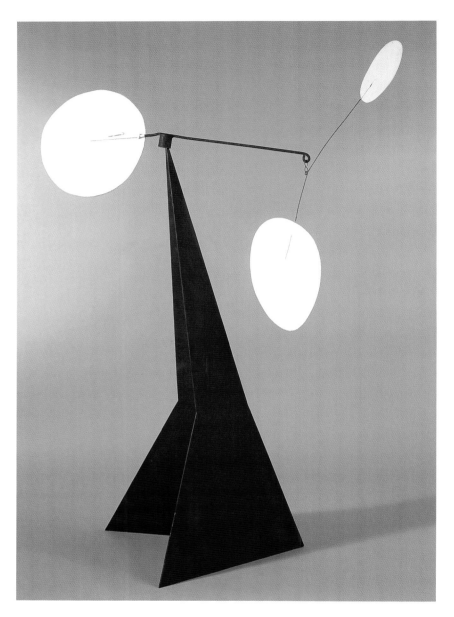

Oshkosh, 1965
Stabile-mobile, H 140 cm
Private Collection
Courtesy Waddington Gallery, London

PAGE 71:
Personage, 1945
Painted metal, 37.4 x 45.7 x 13.9 cm
Private Collection
Courtesy Richard Gray Gallery, Chicago

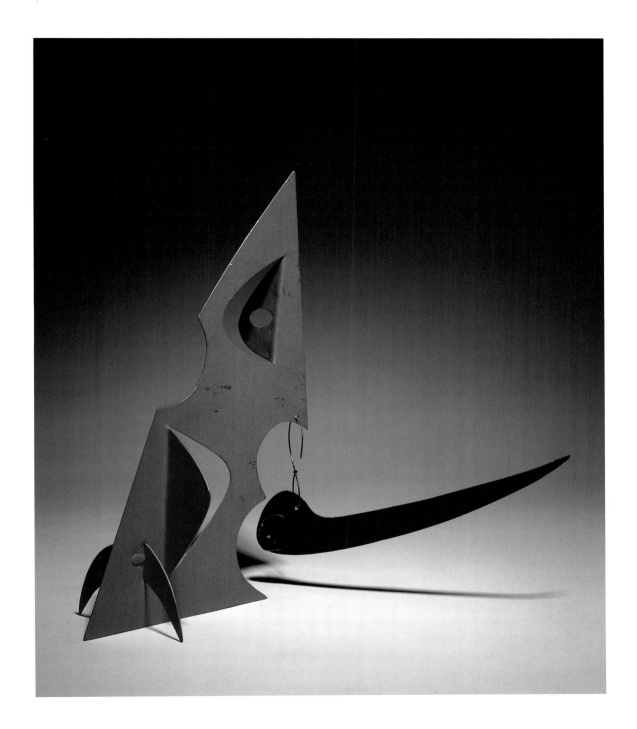

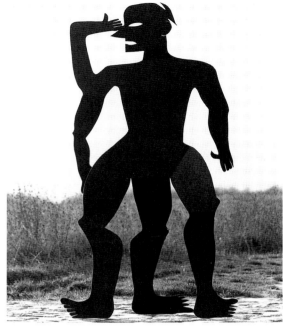

TOP LEFT:
Critter with Square Shoulders, 1974
Critter, painted metal, 190.5 x 96.5 x 68.6 cm
Private Collection
Courtesy Waddington Gallery, London

TOP RIGHT:
Critter Peau Rouge, 1974
Critter, painted metal, 195 x 98 x 75 cm
Private Collection
Courtesy Waddington Gallery, London

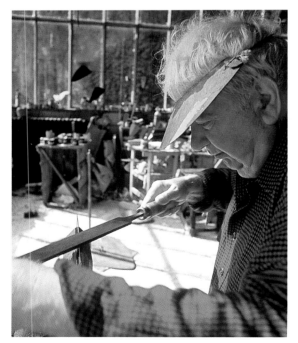

Alexander Calder working on a mobile in his studio, c. 1967
Photo: AKG Berlin/Tony Vaccaro

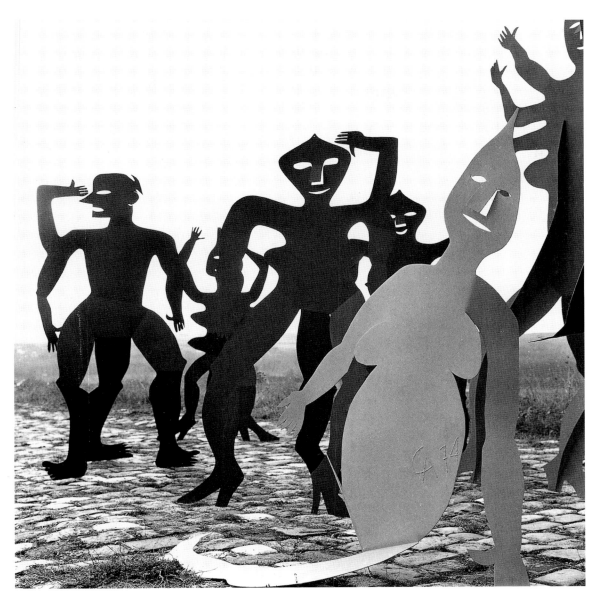

Group of Critters outside Alexander Calder's Studio in Saché (France)
Courtesy Waddington Gallery, London

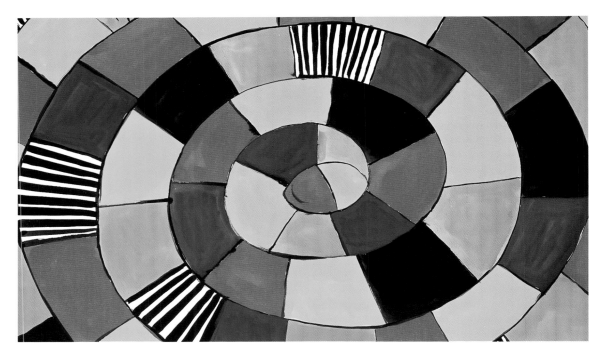

Grid with Symbols, 1966
Gouache and ink on paper, 58 x 73.3 cm
Washington, Hirshhorn Museum
and Sculpture Garden, Smithsonian Institution
Bequest of Joseph H. Hirshhorn, 1986

*"The first inspiration I ever had was the
cosmos, the planetary system."*
ALEXANDER CALDER

PAGE 74 TOP:
Untitled, 1970
Gouache on paper, 76.2 x 109.2 cm
Courtesy Alexander Kahan Gallery, New York

PAGE 74 BOTTOM:
Untitled, 1973
Gouache on paper, 76 x 110 cm
Courtesy Alexander Kahan Gallery, New York

Ace of Spades (As de pique), 1974
Gouache on paper, 74.2 x 109.2 cm
Courtesy Russeck Gallery, Palm Beach (FL)

"I want to make things that are fun to look up at."

ALEXANDER CALDER

PAGE 77:
Icarus, 1974
Gouache on paper, 109.8 x 74.9 cm
Courtesy Jane Kahan Gallery, New York

Spirales, no date
Aubusson tapestry, 168 x 242.9 cm
Courtesy Jane Kahan Gallery, New York

LEFT:
Red Wave (La Vague rouge), c. 1970
Aubusson tapestry, signed Pinton, 156 x 105 cm
Courtesy Jane Kahan Gallery, New York

PAGE 79:
Green Ball, 1971
Aubusson tapestry, 198 x 145 cm
Courtesy Jane Kahan Gallery, New York

Glacier with Coloured Petals, 1971
Aubusson tapestry, 167.6 x 137.5 cm
Private Collection
Courtesy Jane Kahan Gallery, New York

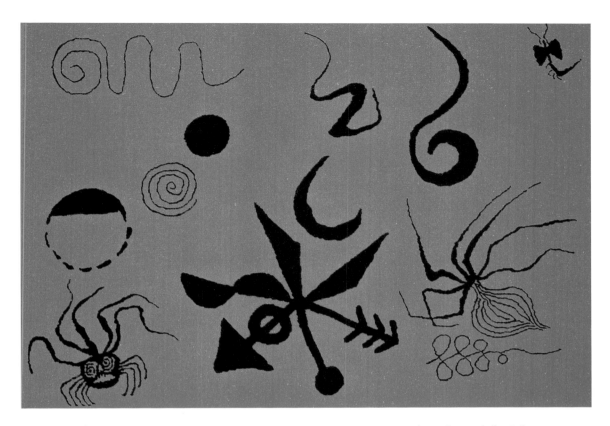

Spider (Araignée), c. 1950
Rug, 150 x 205 cm
Collection Mr. and Mrs. Jacob Baal-Teshuva, New York

*"I love red so much that I almost want to
paint everything red."*
ALEXANDER CALDER

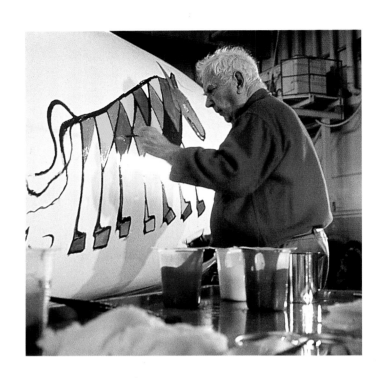

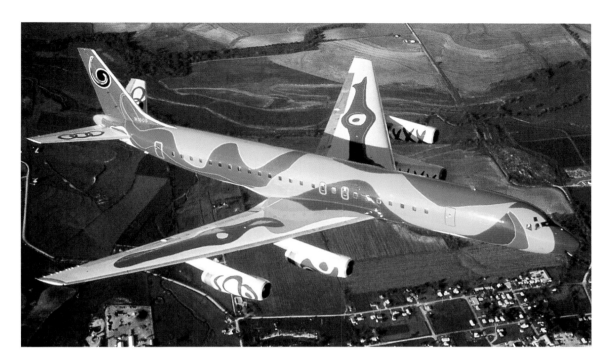

Braniff International DC 8 Airlines jetliner in flight, painted by Calder, 1973
Calder started his commission by working on three small models

"If you can't imagine things, you can't make them, and anything you imagine is real."
<div align="right">ALEXANDER CALDER</div>

PAGE 82 TOP:
Calder painting the engine cover of the DC 8 jetliner commissioned by Braniff International Airlines, 1973

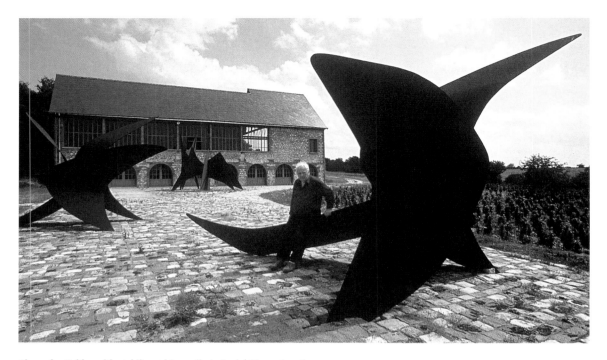

Alexander Calder with stabiles at his studio in Saché (France), 1967
Photo: AKG, Berlin/Tony Vaccaro

*"People keep giving it [Teodelapio] a phal-
lic meaning. I wasn't aware of any such
influence, but that may give it its nice
force."*
<div align="center">ALEXANDER CALDER</div>

PAGE 85:
Teodelapio, 1962
Stabile, painted steel plate, H 15 m
Spoleto (Italy)
Photo: Pedro E. Guerrero

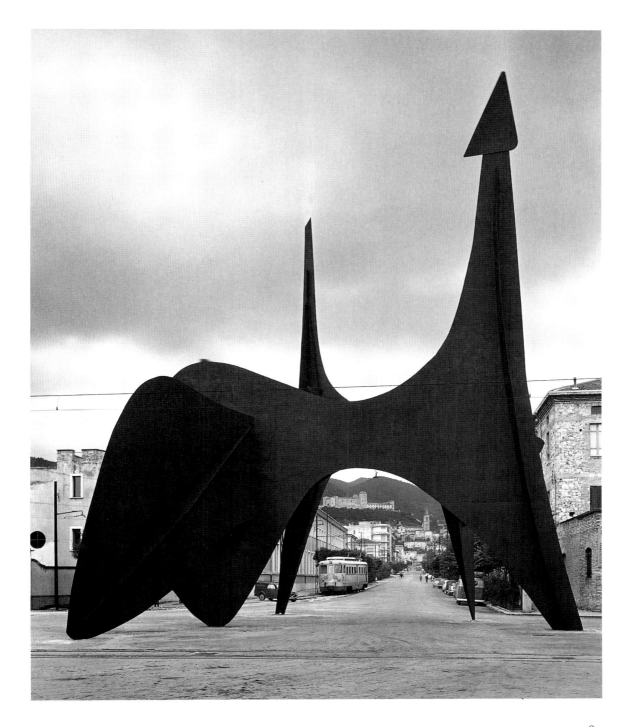

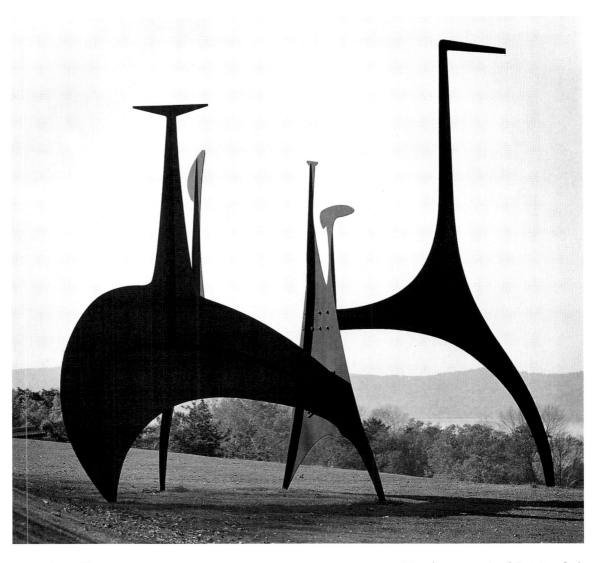

Large Spiny, 1966
Stabile, painted steel, 3.8 x 5.3 m
Tarrytown (NY), Pocantino Hills,
Nelson A. Rockefeller Bequest, the National Trust
for Historic Preservation, Pocantino Historic Area

PAGE 87:
La grande Vitesse, 1969
Stabile, painted steel, H 13.2 m
Grand Rapid (MI), Vanderburg Plaza

"How does art come into being? Out of volumes, motion, spaces, carved out within the surrounding space. Out of different masses ... out of directional lines ..."
ALEXANDER CALDER

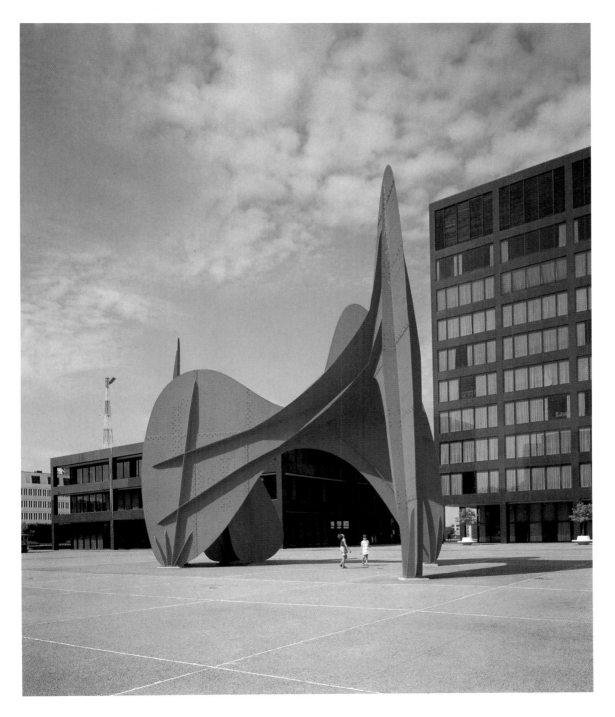

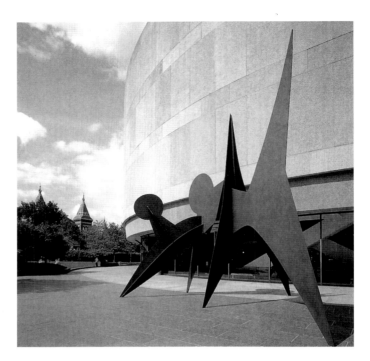

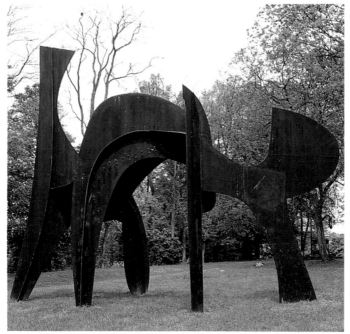

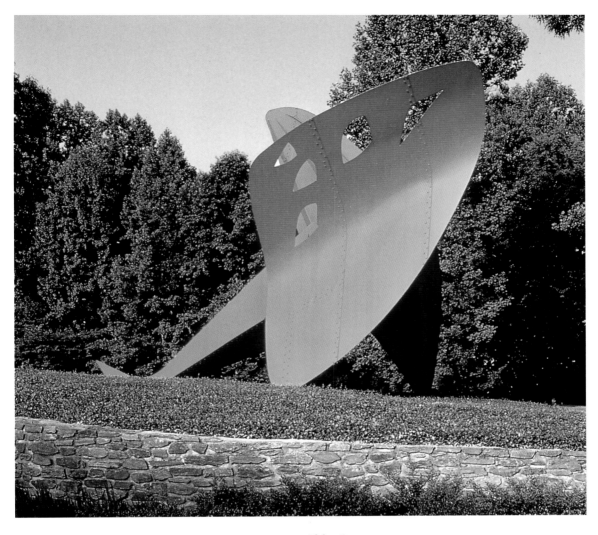

PAGE 88 TOP:
Two Discs, 1965
Stabile, painted steel plate and bolts, 7.7 x 8.3 x 5.2 m
Washington, Hirshhorn Museum
and Sculpture Garden, Smithsonian Institution
Gift of Joseph H. Hirshhorn, 1966

PAGE 88 BOTTOM:
Horn (La Cornue), 1974
Stabile, painted metal, 7 x 7 m
Grenoble (France), University
Courtesy Maître Francis Briest, Paris

Flying Dragon, 1975
Stabile, painted steel, 7.6 x 14.2 x 5.4 m
Collection Mobil Corporation

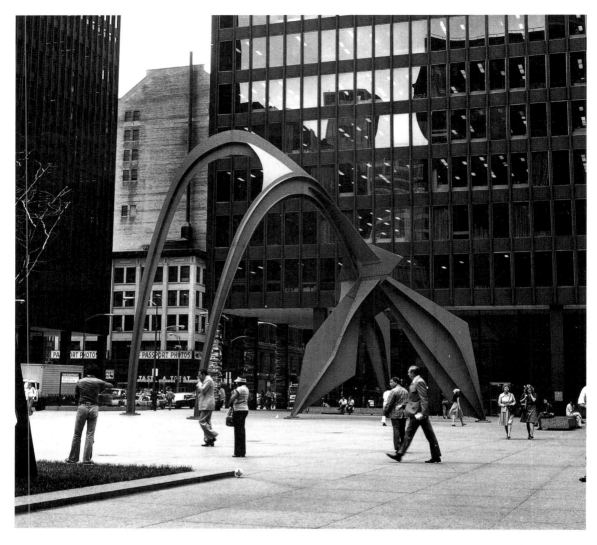

Flamingo, 1973
Stabile, structural steel, 16.2 x 7.3 x 18.3 m
Chicago (IL), Federal Center Plaza
Photo: Roger Viollet, Paris

PAGE 91:
The Jerusalem Stabile, 1976
(dedicated to Jerusalem and its people), painted steel
Donated by Philip and Muriel Berman, Allentown (PA)
Jerusalem, Holland Square
Photo: Courtesy Mr. and Mrs. Philip Berman

"Red because the piece [Flamingo] is set
against a black glass building."
ALEXANDER CALDER

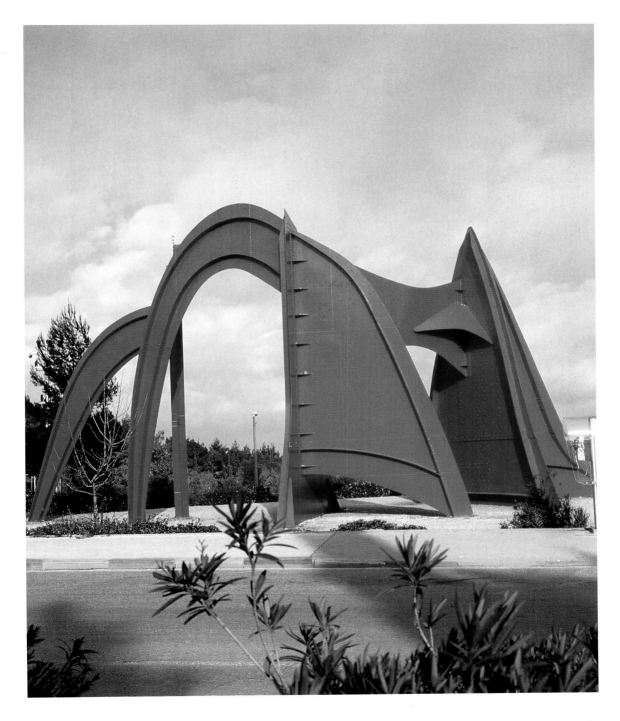

Têtes et queue (Heads and Tail), 1965
Stabile, metal, 550 x 850 x 500 cm
Berlin, Staatliche Museen zu Berlin, Stiftung
Preußischer Kulturbesitz, Neue Nationalgalerie
Photo: AKG Berlin/Hilbich

"... when I use two or more sheets of metal
cut into shapes and mounted at angles to
each other, I feel that there is a solid
form, perhaps concave, perhaps convex,
filling in the dihedral angles between
them. I do not have a definite idea of
what this would be like, I merely sense it
and occupy myself with the shapes one
actually sees."

"I thought of a name for the stabile *Halle-
bardier* as it looks like such a weapon at
the top."

ALEXANDER CALDER

PAGE 93:
Le Hallebardier, 1971
Stabile, painted iron, H 8 m
Hanover, Sprengel Museum

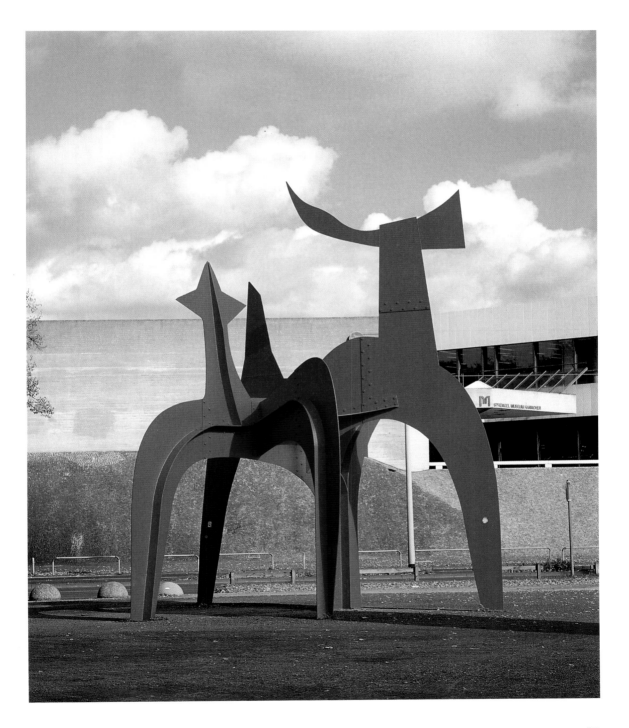

Biography

1898 Alexander Calder is born on 22 July in Lawton, near Philadelphia (PA). His mother, Nanette Lederer Calder, is a painter. His father, Alexander Stirling Calder, as well as his grandfather, Alexander Milne Calder, are well-known sculptors.

1905–1915 His family frequently moves house: Oracle (AZ), Pasadena (CF), New York and finally San Francisco, where his father is commissioned to oversee the sculptural work for the World Fair.

1915–1919 Calder studies at the Stevens Institute of Technology in Hoboken (NJ), graduating in 1919 with a degree in mechanical engineering.

1919–1921 Calder takes a series of jobs in New Jersey, Connecticut and Ohio, none of them lasting very long.

1922 Back in New York, Calder attends drawing classes with Clinton Balmer. On board the *H. F. Alexander*, he sails from New York to San Francisco via the Panama Canal, working as a fireman.

1923 Calder joins the Art Students' League in New York, where he studies until 1925.

1924 Calder works for the *National Police Gazette* as a press illustrator.

1925 Every day for two weeks Calder goes to circus performances put on by the *Ringling Bros and Barnum & Bailey*.

1926 Calder settles in Paris and makes his first wire sculptures.

1927 In spring Calder creates his Circus (ill. p. 16–17). Many artists attend performances of the work.

1928 Calder travels to New York, where his wire sculptures are exhibited. In November Calder moves into a new studio in Paris, where he becomes friends with Jules Pascin and Joan Miró.

1929 Calder's first Parisian solo exhibition in the Galerie Billiet-Pierre Vorms.

1930 After visiting Piet Mondrian's studio in Paris, Calder becomes preoccupied with abstraction.

1931 On 17 January Calder marries Louisa James in the USA. Joins the group *Abstraction-Création* in Paris. During a visit to Calder's Paris studio, Marcel Duchamp christens the moving motor- or air-driven constructions *mobiles*.

1932 In February Calder shows his mobiles for the first time at the Galerie Vignon in Paris.

1933 Gets to know the critic James Johnson Sweeny. Purchases a farmhouse in Roxbury (CT), which from then on becomes the Calders' home in the USA.

1934 First open-air mobile *Steel Fish* (3.5 m high).

1935 Calder's first daughter Sandra is born. Designs mobile sets for Martha Graham's dance *Panorama*.

1936 Various shows, including two group exhibitions in New York's Museum of Modern Art.

1937 José L. Sert commissions Calder to design a fountain for the Spanish pavilion at the World Fair (*Mercury Fountain*).

1938 After an extended stay in London, Calder returns to the United States.

1939 Calder designs a water ballet for the New York World Fair. However, faulty installation prevents its performance. Birth of his second daughter, Mary, on 25 May.

1942 Works on a new open form of sculpture made of carved wood and wire, the *Constellations* (ill. p. 28–29).

1943 James Johnson Sweeney organises a major Calder retrospective in New York's Museum of Modern Art.

1944 Calder illustrates *Three Young Rats and Other Rhymes*, edited by James Johnson Sweeney. He produces a series of plaster sculptures, later to be cast in bronze.

1945 Calder's father dies on 6 January in Brooklyn. He constructs the garden sculpture *Man-Eater with Pennants* for the Museum of Modern Art.

1946 First exhibition after the war in Paris at the Galerie Louis Carré.

1948 The Calders travel to Mexico City, Panama City and Rio de Janeiro. The Museu de Arte Moderna in Rio de Janeiro puts on *Alexander Calder* and the Museu de Arte Moderna in São Paulo also shows works by Calder.

1949 Calder constructs his most ambitious mobile to date, *International Mobile*, for the 3rd International Exhibition of Sculpture in the Philadelphia Museum of Art.

1950 The Galerie Maeght in Paris exhibits 50 mobiles and stabiles. Retrospective at the Massachusetts Institute of Technology.

1952 Calder designs sets and costumes for Henri Pichette's *Nucléa* in Paris. At the 26th Biennale in Venice, Calder wins the grand prize for sculpture. Calder accepts a commission from Carlos Raúl Villanueva to design the

Selected Bibliography

acoustic ceiling for the Aula Magna of the University of Caracas (Venezuela).

1953 Spends a year in Aix-en-Provence and concentrates on gouaches. Buys a house in Saché (France).

1955 Three-month stay in India. Sandra Calder marries Jean Davidson.

1957 The Calders buy an old customs house "Le Palud", at the mouth of the Tréguier River in Brittany. Calder produces a giant mobile for the entrance hall of New York's John F. Kennedy airport and the maquette for a stabile-mobile for the headquarters of UNESCO in Paris (ill. p.41).

1958 For the World Fair in Brussels, Calder constructs *Whirling Ear*. Calder is awarded the Carnegie Prize for sculpture in Pittsburgh.

1959 Major exhibition of stabiles at the Galerie Maeght in Paris.

1960 His mother dies in Roxbury at the age of 93.

1961 Carlos Vilardebo shoots a colour film about Calder's Circus with narration by Calder. Calder's second daughter, Mary, marries Howard Rower.

1962 In Saché, Calder begins building a spacious studio.

1964 A major retrospective at the Guggenheim Museum in New York shows Calder at the height of his fame.

1965 Calder is elected member of the American Academy of Arts and Letters.

1966 On behalf of the peace movement *Artists for Sane*, Calder organises a whole-page advertisement in the New York Times. His autobiography is published.

1967 Calder realises important monumental works.

1968 Calder's stabile *El Sol Rojo* (The Red Sun) is installed at the Olympic Games in Mexico.

1973 Calder paints a Braniff International Airlines DC-8 jetliner.

1974 Erection of the monumental stabile *Flamingo* on Federal Center Plaza and of the large-scale motor-driven installation *Universe* in the Sears Roebuck Tower in Chicago.

1976 The Whitney Museum in New York organizes a major retrospective. Calder dies on 11 November in New York, aged 78.

Calder's Writings and Statements

Calder, Alexander. *Animal Sketching*. New York, 1926.

Calder, Alexander. "Voici une petite histoire de mon cirque." In: *Permanence du Cirque*. Paris, 1952, 37–42.

Calder, Alexander, with Jean Davidson. *Calder, An Autobiography with Pictures*. New York, 1966.

Books

Arnason, H. Harvard and Pedro E. Guerrero. *Calder*. New York, 1966.

Bellew, Peter. *Calder*. Barcelona, 1969.

Bourdon, David. *Calder: Mobilist, Ringmaster, Innovator*. New York, 1980.

Lipman, Jean, with Margaret Aspinwall. *Alexander Calder and his Magical Mobiles*. New York, 1981.

Marter, Joan M. Alexander. *Calder*. Cambridge, 1991.

Pierre, Arnaud. *Calder: La sculpture en mouvement*. Paris, 1996.

Rower, Alexander S. C. *Calder Sculpture*. New York, 1998.

Exhibition Catalogues

Abadie, Daniel and Pontus Hulten. *Alexander Calder: Die Grossen Skulpturen*. Kunst- und Ausstellungshalle Bonn, 1993.

Alexander Calder (1898–1976). Moderna Museet, Stockholm, 1996.

Alexander Calder: Retrospective. Fondation Maeght, Saint-Paul-de-Vence, France, 1969.

Alexander Calder: Retrospective. Louisiana Revy 36, no. 1. Louisiana Museum of Modern Art, Humlebaek, Denmark, 1995.

Alexander Calder: A Retrospective Exhibition. Solomon R. Guggenheim Museum, New York, 1964.

Alexander Calder: Sculptures of the Nineteen Thirties. Whitney Museum of American Art, New York, 1988.

Alexander Calder, stabilen, mobilen. Stedelijk Museum, Amsterdam, 1959.

Calder. Fundació Joan Miró, Barcelona, 1997.

Calder. Haus der Kunst, Munich, 1975.

Calder. Musée National d'Art Moderne, Paris, 1965.

Prather, Marla. *Alexander Calder: 1898–1976*, National Gallery of Art, Washington, 1998.

Front cover:
Four White Petals, c. 1947
Stabile-mobile, painted metal, 41.9 x 24 x 36.8 cm
Private Collection
Courtesy Waddington Gallery, London

Back cover:
**Alexander Calder with one of his
monumental mobiles in the garden
of his home in Saché (France)**, 1967
Photo: AKG/Tony Vaccaro, Berlin

Front flap:
Poissonagerie, 1969
Mobile, painted metal, 200 x 145 cm
Private Collection, Israel

Back flap:
Aspen, 1948
Standing mobile, painted sheet metal,
rod and lead weights, 96.5 x 63.5 x 78.7 cm
Private Collection
Courtesy Christie's, New York

Illustration page 1:
Red Crescent (Croissant Rouge), c. 1951
Stabile, painted metal, rod, wood, 165.7 x 48.2 cm
Collection José Mugrabi, New York

Illustration page 2:
**Calder with models of his mobiles and stabiles
in his studio in Saché (France)**, 1967
Photo: AKG Berlin/Tony Vaccaro

© 1998 Benedikt Taschen Verlag GmbH
Hohenzollernring 53, D-50672 Köln
© 1998 VG Bild-Kunst, Bonn

Cover design: Claudia Frey, Cologne
Editing and layout: Bettina Ruhrberg, Cologne
Supplementary editing: Chris Goodden, Bungay, UK
Production: Martina Ciborowius, Cologne

Printed in Portugal
ISBN 3-8228-7642-9
GB